IMAGES
of America

FALMOUTH

On the cover: Today one purchases the necessities of life at a supermarket or super store. Such was not the case for most 150 years ago. People lived on the land and depended upon it to produce food for families and for horses and cattle. Haying was a very important activity. The weather played an important part in growing, cutting, and storing hay. This family has paused in their work for a moment to have their picture taken. Over the years, the Hamilton, Peterson, and Walton families have lived on this farm. (Courtesy Falmouth Historical Society.)

IMAGES
of America

FALMOUTH

The Falmouth Historical Society

ARCADIA
PUBLISHING

Published by Arcadia Publishing
Charleston SC, Chicago IL, Portsmouth NH, San Francisco CA

Printed in the United States of America

Library of Congress Control Number: 2008931208

For all general information contact Arcadia Publishing at:
Telephone 843-853-2070
Fax 843-853-0044
E-mail sales@arcadiapublishing.com
For customer service and orders:
Toll-Free 1-888-313-2665

Visit us on the Internet at www.arcadiapublishing.com

*This book is dedicated to all those in the past who have contributed
to the history of Falmouth and to those who are now creating it.*

CONTENTS

ACKNOWLEDGMENTS

The authors of *Falmouth* give special recognition to Charlotte Wallace, Donald Wallace, Sarah O'Brien, Ruth Serber, Helen Knight, and Dorothy Jenkins, former members of the Falmouth Historical Society (FHS), who contributed greatly to its archives. A special thank you is noted to the newspapers in the area that have featured Falmouth history over the years. They are the Portland Newspaper Company, the Forecaster, and the Notes. The Falmouth Memorial Library (FML) shared postcards, books, and the knowledge of library director Lynda Sudlow. A final note of appreciation goes to all of the Falmouth families who entrusted us with their precious photographs and memories. In addition to many of the authors, we received photographs for consideration from Eunice Dusty, Peter Jeffery, Carla Silverman, Michael Morrison, Dorothy Bates, Sherry Cleaves, the Scanlon family, Tim Woodruff, Ruth Norton, and Coleen Whitney. The authors, members of the Falmouth Historical Society, include Gerald Davis, Dorothy Fredriksen, Mary Honan, Carol Kauffman, Beverley Knudsen, Donna Little, Lyn McKenzie, Richard McKenzie, Scott McLeod, David Merrill, Nancy Merrill, Hannah Russell, Matha Southard, Lynda Sudlow, and Elizabeth Winslow.

INTRODUCTION

Falmouth is located on the coast north of Portland. The town of Cumberland is to the north, and the town of Windham is to the west. On the south are Westbrook and Portland. The Maine Turnpike, Interstate 295, U.S. Route 1, and U.S. Route 100-26 are the north–south transportation corridors. The area of the town is approximately 32 square miles. It has a population of just over 11,000 persons. Two rail lines run through Falmouth, but there is no passenger service.

Falmouth has no heavy industries or manufacturing plants. Health care facilities, retail stores, automobile sales and service, small business firms, and professional offices are the major employers of the community. In addition, the town government, the school system, and the senior residential facilities employ many people. Many Falmouth residents are employed throughout the greater Portland area.

The General Court of Massachusetts established the town in 1658 and named it after Falmouth, Cornwall, England at the mouth of the Fal River. Town activities were suspended during the Indian Wars between 1675 and early 1700s. The town was established again in 1718 with the same borders. As people moved back to previously settled areas, parts of Falmouth then had enough people to separate and form a new town. The Cape Elizabeth–South Portland Area was organized into a town in 1765, Portland left in 1785, and finally, Westbrook left in 1814. The New Casco area became the town of Falmouth, with approximately its present size.

Most of the pictures in *Falmouth* seem to have been taken after 1880. It may be helpful for the reader to have an idea of some of the events prior to that time.

The writing of Marco Polo about his journey to China and return stimulated enormous interest in Europe. Christopher Columbus was looking for a passage to China by sailing westward from Europe. In 1498, John Cabot sailed from England but found no Northwest Passage, gold, or silver. He did claim territory for the crown.

By the late 1500s, the dream of finding the Northwest Passage faded. English explorers were then looking for resources that were in demand in England. Three seemed readily available: furs, fish, and white pine trees for masts.

Two English joint stock companies petitioned and received a charter from King James I in 1606. The London Company was to establish colonies south of the Hudson River. It established the colony of Jamestown in 1607, which survived after much struggle and many hardships.

The Plymouth Company was to establish colonies north of the Hudson River. It established Popham in 1607, which existed for less than two years and then was abandoned. Its primary contribution was the building of a small ship, the *Virginia*. The Plymouth Company went into decline.

A new charter was issued in 1620 to the reorganized Plymouth Company, which was then called the Plymouth Council for New England. Sir Fernando Gorges was the leader who obtained rights to develop the area between the Kennebec River and the Piscataqua River on the border between Maine and New Hampshire.

Charles I became the next king in 1625. One of his first acts was to rescind the 1620 charter and issue a new one with a new cast of characters who were friendly to him. He began a long battle with Parliament over changes in the Church of England. He was finally beheaded.

In Falmouth, the land ownership problems continued to cause confusion and distress. Gorgas and his group were out of favor, but the population had grown. An organized, elected government was needed. In 1658, the General Court of Massachusetts recognized the area between the Spurwink River to the south and a white rock to the north as the seventh town in Maine and named it Falmouth. The northern part of this area was called New Casco. The town line ran inland for eight miles. Falmouth turned 350 years old in 2008.

People continued to arrive in the area. Survival was mostly by hunting and fishing. Clearing of land and planting of crops was a much more time-consuming task. The Native American population remained, but they were in competition for food sources. Tensions mounted over the years, and in 1675, King Phillip's War began along the East Coast. People were killed or carried off, and houses and buildings were burned out. This problem continued for 50 years or more. The settlements along the Maine coast were destroyed, including Fort Loyal and the village on Falmouth Neck.

Both the Native Americans and the white settlers were pawns in the continuing warfare between France and England. Treaties were signed, peace ensued, hostilities broke out, and this pattern continued until the start of the French and Indian War in 1765.

People returned slowly to the area. New Casco did not begin to have many people until the 1730s. The period is noted for its continuing difficulties with the French, Native Americans, and the American Revolution. The embargo acts and the War of 1812 were a disaster to the economy. Finally it should be noted that the birth of Maine as a state in 1820 was part of the Missouri Compromise.

Town governments could then set up rules and regulations, collect taxes, and hold elections. The key problem was providing food, clothing, and shelter for families. Educating children and being able to move surplus farm products to market were important steps. Falmouth had at least 10 neighborhood schools offering education through the eighth grade.

According to a document in the Falmouth Historical Society's files, "Around 1780, Falmouth overall had: 669 Voters, 434 Buildings, 3,945 acres of mowing land and 4,175 acres of pasture. It had 15,297 acres of Woodland. There were 10 wharves, 11 mills, 291 Horses, 1039 Cows, 649 Oxen, 4729 sheep, 576 swine. There were 460 carriages of all sorts. Vessel tonnage was 1,225. Goods and merchandise owned totaled $27,000 and money on hand $32,000."

Mills and Dams continued to be built. There were wood mills, gristmills, pulling mills, a silk mill, a brickyard, and other operations along the Presumpscot River and the Piscataqua River in West Falmouth. Shipbuilding was a growing industry with shipyards along the Presumpscot River as well as on the Foreside.

The lowering of the hostility level with the British and Native Americans allowed settlers to push farther into the interior. By the Civil War, lower Maine was well settled. Families were large, and numerous people joined religious groups and moved out of the state, while others went to California for the gold rush. Later the lure of cheap land in the West and jobs in other states kept Maine's population low. Falmouth had a boost in 1847 as the railroads were extended north through the town. An even greater boost came with the introduction of the electric trolley in 1899. For the first time, anyone could travel speedily in relative comfort and ease to shop, visit, or to work outside of Falmouth. The automobile added another dimension to travel. It set the stage for Falmouth to become a residential community of the Greater Portland Area.

One

EARLY DAYS

In 1606, King James I of England granted a charter founding the Virginia Company. The charter was a legal document giving specified individuals exclusive rights to the development and exploitation of land taken in the name of the English crown. It had two parts. The Plymouth Company was to establish settlements from the Hudson River north, and the London Company was given land from the Hudson River south. In 1607, the Plymouth Company established Popham Colony in what is now the town of Phippsburg. It lasted less than two years because its leadership group experienced deaths and personal problems in England. It was a business proposition. One lasting result was the building of the first boat in America, the *Virginia of Sagadahoc*, a pinnace. It survived and sailed to England. Later it carried supplies to the colony at Jamestown. In 1607, the London Company established the Jamestown Colony. It had a more desperate time than Popham but managed to survive. In 1620, the Plymouth Company was reorganized after years of inactivity as the Plymouth Council for New England. Its leaders were Sir Fernando Gorges and Capt. Christopher Levett. This group did not seem to sponsor any further group efforts to form colonies. Grants were being made to people who then took up individual plots of land. The Pilgrims' colony at Plymouth was chartered by the London Company for settlement at the mouth of the Hudson River, but circumstances and weather brought them to New England. A few years later, the Pilgrims received a charter to the land from the Plymouth Council for New England. In 1622, Levett sailed into Casco Bay and claimed land for his own settlement. He was a naval captain and was perhaps the most knowledgeable forester in England. He had written a definitive book about the care and development of forests in England. The king was delighted when Levett became part of the Plymouth Council for New England. There is a definite relationship to his being in this area to oversee the harvesting of the great white pines for the king's navy.

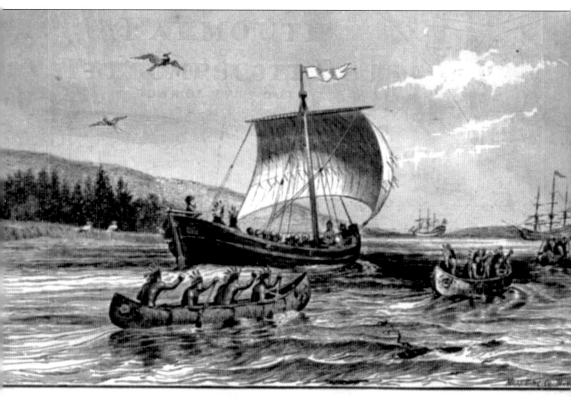

CAPT. CHRISTOPHER LEVETT STEERING HIS SHALLOP INTO HOG-ISLAND-ROADS, 1623.

In 1623, Capt. Christopher Levett explored the Maine Coast. He was a member of the reorganized Plymouth Council for New England, an agent for Sir Fernando Gorges, and an authority on forestry. Levett received a grant of 6,000 acres. He selected Hog Island in Casco Bay as part of his grant and proposed to establish a settlement on the mainland called York after his hometown. He made friends with the Native Americans and treated them fairly. He invited the sagamore of the local tribe to accompany him to his chosen site. William Goold's *Portland in the Past,* records Levett's famous quote, "The next day the winds came fair and I sailed to Quack or York [Portland] with the king, queen, prince, 3 bows and arrows, dog, kettle, in my boat. His noble attendance, rowing by in their canoes." Men from his ship began to build houses on the island. After 18 months, Levett returned to England for his family and other settlers. He left 10 men behind, but he never returned to the area, and no record remains of those left behind. (Courtesy FHS.)

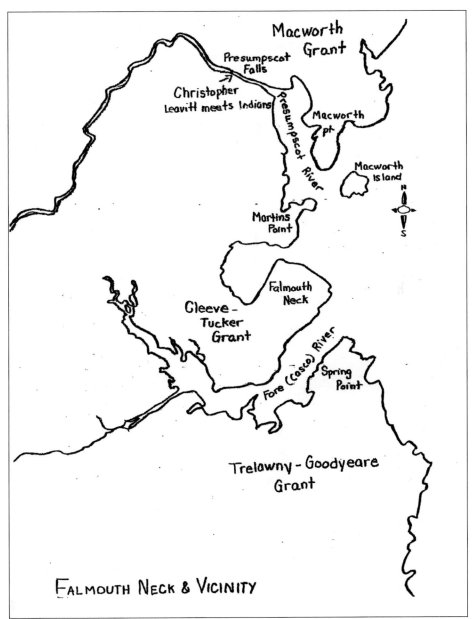

Falmouth Neck & Vicinity

In 1622, the reorganized Plymouth Council for New England granted land patents to Sir Fernando Gorges and John Mason. Through an agreement with Mason, Gorges received the territory from the Piscataqua River (now the border of Maine and New Hampshire) to the Kennebec River. All grants in the ancient Falmouth area stemmed from land granted to Gorges. Arthur Mackworth received a grant in 1632 that included Mackworth Island and a large tract of land on the mainland (lower Foreside). He built a house on the island and one on the mainland on Menekoe Point where he lived with his wife, Jane, and their family until his death in 1657. His widow lived in the mainland house until she moved to Boston at the beginning of the Indian Wars in 1675. The Cleeve-Tucker grant was on Falmouth Neck at the base of Munjoy Hill in what is now Portland. The Trelawney-Goodyear grant covered all of what is now Cape Elizabeth and part of Falmouth Neck. (Courtesy FHS.)

11

This photograph shows a painting made by Roger Deering in 1886. Labeled *Squitterygusset*, it is one in a series portraying Maine Native American chiefs. Squitterygusset spring and pond remain off Lunt Road along the thruway. A dirt road leads down to a pond of fresh water. This area was the summer home of the chief and his tribe in the early days of Falmouth. (Courtesy FHS.)

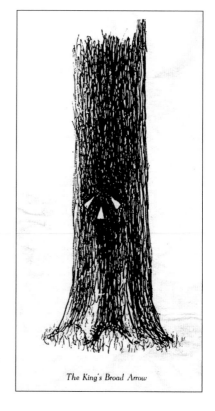

The King's Broad Arrow

The king's foresters roamed the wooded areas marking white pine trees 24 inches or more in circumference. The king's broad arrow was the marker. These became masts for ships in the king's navy. It was a crime for anyone to cut down these marked trees. Some rebellious folk cut the trees, used them for their own needs, and burned the arrow marks in celebration. (Courtesy FHS.)

In 1658, the General Court of Massachusetts assumed control over the grants, including the area controlled by Sir Fernando Gorges. The court created a town and named it Falmouth. The northern boundary was a white rock on the shore at the present line with Cumberland and a red Oak tree on Clapboard Island. To the south, the border was the Spurwink River. The town line then ran inland for eight miles. (Courtesy FHS.)

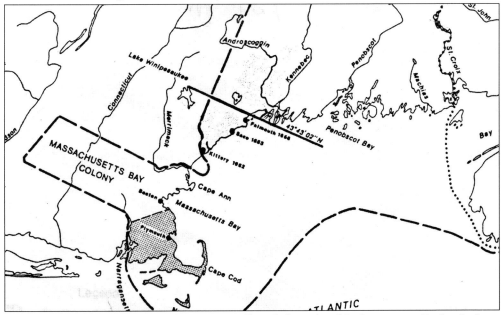

Reflecting the ascendancy of Oliver Cromwell and the rule of Parliament in England, those who had depended upon the largess of the king were now in disfavor. Included in this group were Gorges and his associates. Gorges died destitute in 1647 without achieving his colonial aspirations. The Massachusetts Bay Colony, under a new charter, acquired jurisdiction over the province of Maine, the grant area formerly controlled by the Gorges group. (Courtesy FHS.)

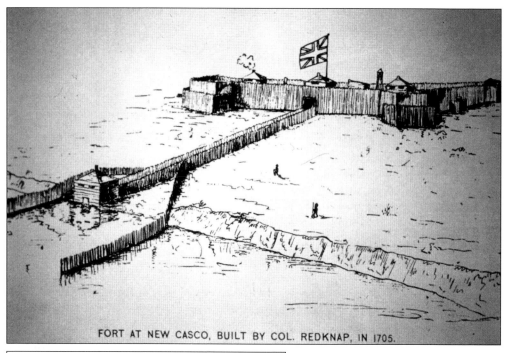

FORT AT NEW CASCO, BUILT BY COL. REDKNAP, IN 1705.

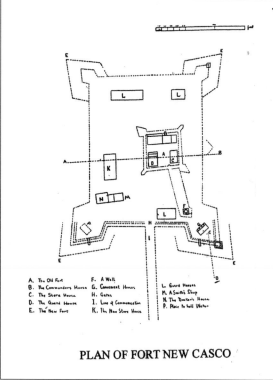

A. The Old Fort
B. The Commanders House
C. The Store House
D. The Guard House
E. The New Fort
F. A Well
G. Convenient Homes
H. Gates
I. Line of Communication
K. The New Store House
L. Guard Houses
M. A Smiths Shop
N. The Doctor's House
P. Place to hold Water

PLAN OF FORT NEW CASCO

In 1675, Native Americans in the coastal colonies took action as English settlers encroached upon tribal lands. A peace treaty was signed, but hostilities broke out again. Nine members of the Wakely family living in the Presumpscot Falls area were tortured and killed. The next day, other houses were destroyed, and all inhabitants were killed. This pattern was repeated many times. By 1690, with the destruction of Fort Loyal on the Falmouth Neck (Portland), no known settlers remained in ancient Falmouth. In 1700, a new and larger Fort New Casco was built to include the old, smaller fort erected on the current grounds of the Portland Country Club. In 1703, a large force of French and Native Americans attacked the fort. The arrival of a British warship with guns blazing caused the enemies to withdraw. The fort was dismantled in 1716. (Courtesy FHS.)

Two

THE TOWN OF FALMOUTH

The name Falmouth was given to the town when it was established by the Massachusetts Bay Company in its proclamation of 1658, which organized the province of Maine. Legend says it was named by individuals from the town of Falmouth at the mouth of the River Fal in Cornwall, England. That town was established in 1613. It is unknown who those people were or whether they actually came as settlers to the area of what is now Falmouth, Maine. The two towns have many similarities: Both have deep, natural harbors; both are seaports with facilities for cargo handling; both attract many large cruise ships each year; and both have played important roles in the history of their countries.

Noted earlier were the building of Fort New Casco, the attack by French and Native American forces, and the repulsion of this group by the arrival of a British warship. Records are sparse as to when specific individuals and families moved back into the New Casco area of Falmouth. By 1726, one family may have been here. It may have been well into the 1830s before families that had fled south to New Hampshire and Massachusetts began to move back to previous localities.

Although Falmouth is no longer thought of as being divided into separate villages, it is necessary and helpful to tell the story of Falmouth in the manner in which it developed. This section will cross the Presumpscot estuary at Martin's Point and move up along the shore on Route 88, Foreside Road. It will also discuss the Presumpscot River and village Falmouth Corners. West Falmouth and the town government will complete this section.

The current town hall was built in 1899 and renovated many times during its lifetime. In 1962, the council-manager form of government was established. Since that time, Falmouth has had a town manager that is responsible for its day-to-day operations.

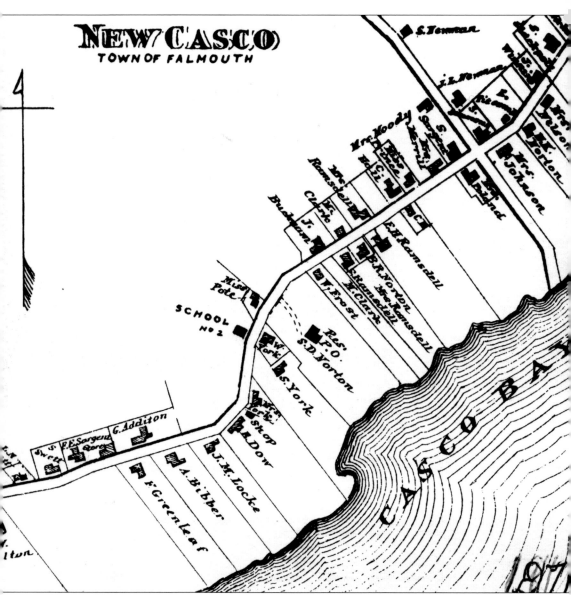

NEW CASCO
TOWN OF FALMOUTH

New Casco was the post office for Falmouth's shore from Mackworth Point to the Cumberland border. Old State Road (Route 1) was the main road along the Foreside. The lower Foreside was flat with several large farms and garden areas. The mid-Foreside was comprised of summer homes and estates on the water. The smaller homes and farms along the road were occupied by the year-round residents who catered to the summer residents. The upper Foreside had a large summer hotel and later the Underwood Spring Park. The electric trolley, running from Portland to Yarmouth, provided a new outlook for the Foreside area. Residents could now ride to work and shop in Portland. During World War II, the population of the town increased with war workers and naval personnel. After the war, pleasure boating activities increased, and the town landing became the mooring area for hundreds of vessels. Along the Foreside, the Portland Country Club, the Portland Yacht Club, the Handy Boat Yard, and many private residences enjoy the view of beautiful Casco Bay. Most homes in Falmouth are now occupied year-round. (Courtesy FHS.)

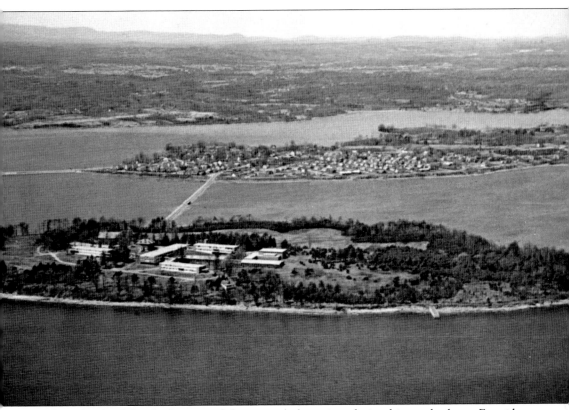

Mackworth Island (at the bottom of the picture) shows its relationship to the lower Foreside, the Presumpscot estuary, and the far shore. Arthur Mackworth, the first Falmouth settler, built a house on the island and one on the lower Foreside. Gov. Percival Baxter built his home on the island. Later he gave the island to the state, which established the Governor Baxter School for the Deaf. The school buildings are seen in the foreground. A mile walk around the island is a popular outing for many in this area. The bridge linking Martin's Point to Falmouth is visible at mid-left as it brings Route 1 into Falmouth. It continues past the many houses. Tall Elms Farm and the Maine Audubon Society are located in the wooded area to the right before Route 1 connects with Route 88. The Pleasant Hill area is visible in the upper-right corner. In the upper part of the picture, one can see many lakes and ponds and the dim outline of the White Mountains in New Hampshire. (Courtesy F. L. Johnstone.)

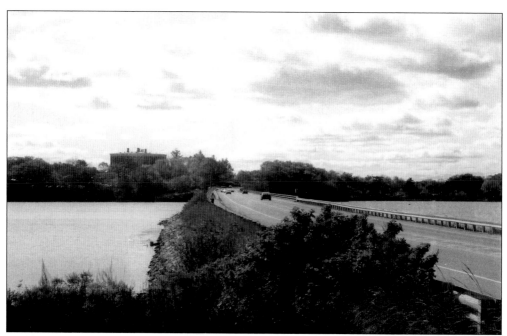

Petitions for a bridge between Martin's Point and Mackey's (Mackworth) Point began in 1807, but the embargo act, the War of 1812, and a depression delayed its building until 1828. Huge chunks of ice destroyed this toll bridge in 1861 just as the Civil War began. Rebuilt after the war at county expense, it opened as a free bridge in 1868. Wooden piles, placed in the river upstream to break up the ice flows in winter, became convenient for cormorants to perch upon and dry their wings. The old tollhouse, no longer needed, was moved across the road and became a private home. This interior picture shows the drawer in the wall that was pushed out to receive toll money and then pulled in to retrieve it. (Courtesy FHS.)

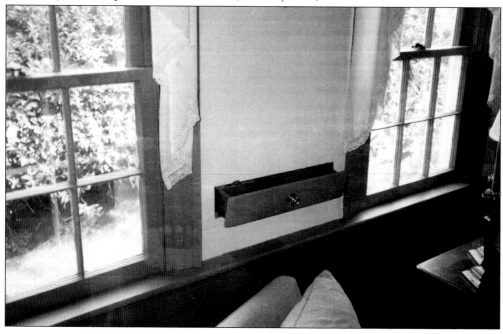

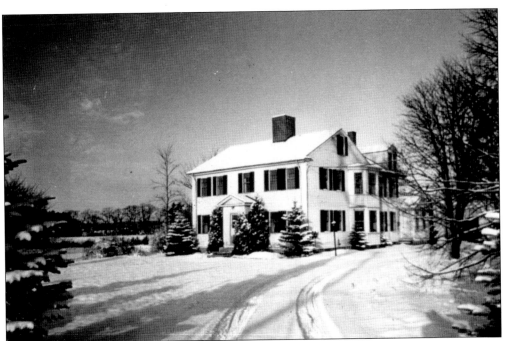

Tall Elms Farm began before 1750. The house has a different pattern of molding in every room and a fireplace (in every room but one) with a mantel design that matched the molding. The house has been altered over the years. The barn and pond remain. It was a working farm at one time, ships were built on the property and there was a tidal mill. The farm was the home of Lucille Johnstone, a direct descendant of the early owners. She was an airplane pilot and a photographer who took many pictures that were made and sold as postcards. Several of these appear in this book. Johnstone's father was involved with Falmouth businessmen importing Jersey cows. These cows graze in a field that is now the site of the Foreside Commons. (Courtesy F. L. Johnstone.)

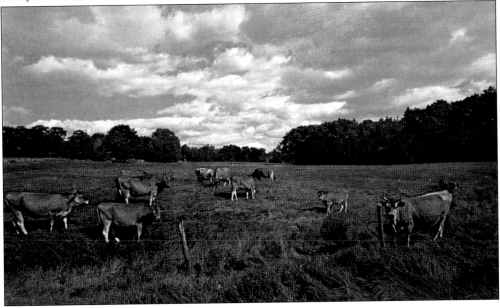

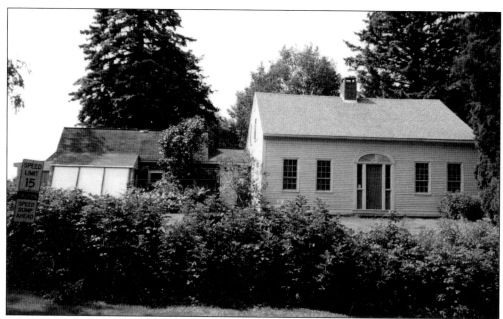

Gilsland Farm is a nature preserve on the banks of the Presumpscot estuary and is the headquarters of the Audubon Society of Maine. In 1911, David Moulton bought the property and named it Gilsland Farm in honor of Sir Thomas de Moulton of the Gils, a character in Sir Walter Scott's novel *The Talisman*. He imported Jersey cattle. The land was deeded to the Audubon Society of Maine in the 1970s. (Courtesy FHS.)

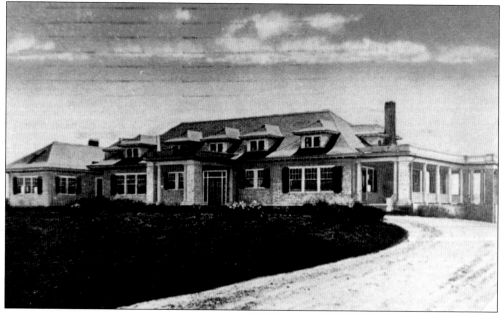

The Portland Country Club relocated to Falmouth in 1913 on 142 acres between the State Road and the shore. Members created a classic golf course, tennis courts, a swimming pool, and a spacious clubhouse for dining and entertaining. The club shares a historic locale in Falmouth history. The property was the site of an early garrison house for trading with Native Americans, and in 1700, it became the larger Fort New Casco. (Courtesy FML.)

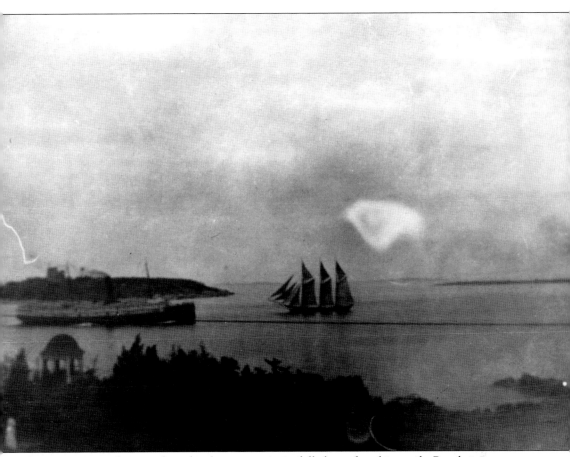

It is a rare treat when a sailing ship leaves port in its full glory of working sails. People in summer colonies on the islands come running to porches and hilltops. Some observers simply enjoy the beauty of the passing ship powered by the wind. Someone took this picture of the passing ships, fixing a moment in history of a time that has long passed. This three-masted ship is passing the steamship opposite the Thornhurst estate. No one knows the names of these ships or their destination, but old timers remember sailing ships taking lumber and cargo from Maine to the Neponset Docks in Boston as recently as 1942. Shipbuilding has been an activity in Maine for a long time. Special ships to carry masts to England were built near here before the American Revolution. Over the years, shipyards on the Presumpscot River and in the estuary have built hundreds of ships. (Courtesy FML.)

PINES FALMOUTH FORESIDE, ME.

Pine Grove Park on Route 88 is a 27-acre wooded park with walking paths and memorials to war victims. Each year on Memorial Day, hundreds of Falmouth residents representing the Boy Scouts, the Girl Scouts, the Shriners, the Antique Car Club, the Falmouth Historical Society, the Falmouth Memorial Library, the American Legion, and other local groups march to the park. Hundreds of others line the road to cheer on the marchers and then join them for the annual Falmouth Memorial Day ceremony. The American Legion memorial reads, "In honor of all who served their country, Falmouth Memorial Post 164, Dedicated May 30, 1966, Remember them forever with a grateful heart." There is a plaque in memory of two young men who were volunteers during World War I and lost their lives fighting for liberty. Henry Howard Huston Woodward, who flew for the French Army's Lafayette Flying Corps, died in combat at Montdider on April 1, 1918. According to the plaque, Henry Howard Huston of the "2nd First Lieutenant Headquarters staff 53rd Field Artillery 28th Division" was killed in action near Fismes, France, on August 18, 1918. (Courtesy FML.)

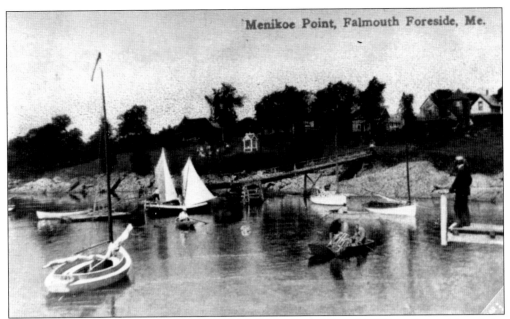

Waite's Landing on Menekoe Point received its name from Albert G. Waite who petitioned the town of Falmouth in 1888 for permission to build a wharf at the end of his property. This became a busy spot for families in the neighborhood to use their boats for business or pleasure. Note the two men dealing with a lobster trap. Remnants of the wooden pier still stand at Waite's Landing and bring memories of ferries and steamboats stopping there. Cottages line the shore in this postcard from the dawn of the 20th century; these are now year-round homes. Samuel J. Cobb's shipyard once built special mast ships for the king near here. Later other shipbuilders turned to the coast when bridges cut off their exit from the river. (Above, courtesy FML; below, courtesy Adele Robinson.)

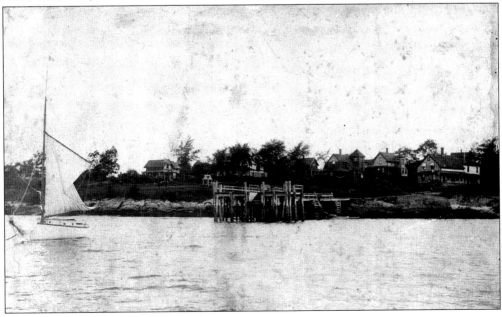

Charles and Alexander Skillin, sons of Silas Skillin, started Skillin's Greenhouses in 1885 when they began selling vegetables to the summer people along the Falmouth shore. Alexander Skillin Jr.'s sons John and David expanded the operation. Today fourth-generation members of the Skillin family are still operating the business. The main store is located at Depot Road and Route 88. This is the oldest continuously operated business in Falmouth. (Courtesy FHS.)

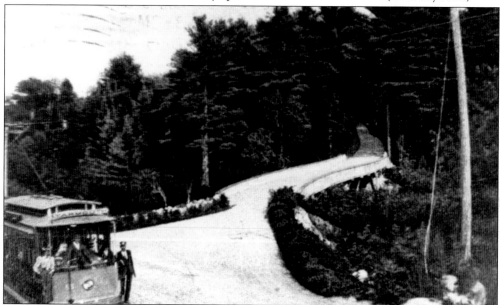

This trolley is at the entrance to Stonecroft, the Payson estate. It probably has passengers from Underwood Spring. Service was good along the Foreside, and children often took the trolley to school. Mothers trusted the conductor to make sure their children got off at the right place. By the end of September of each school year, he knew where each child would "be picked up and dropped off." (Courtesy FML.)

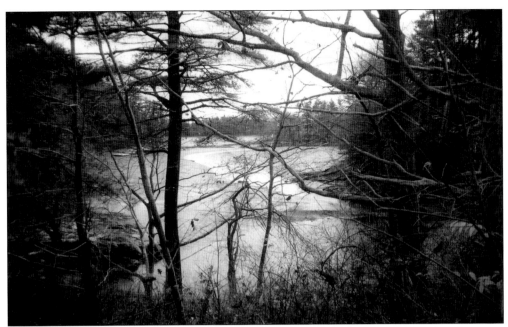

Mill Creek on the Falmouth Foreside drains the area between Route 1 and Route 88 and empties into Casco Bay at Mussel Cove. This view of Mill Creek, taken from Foreside Road, shows its tidal nature. As early as 1710, George Felt and Samuel Bucknam had a tidal mill at the cove, and in 1728, Benjamin Blackstone built a sawmill on the creek. Others involved in building sawmills, gristmills, and dams throughout the 1700s were James Buxton, William Bucknam, Nathan Bucknam, Joseph Noyes, and Nathanial Knight. Job Ramsdell built a tidal gristmill in 1836. A narrow opening of the inlet makes it easy to construct a plank dam. The twice daily 9-to-10-foot tide added to the natural flow of the creek. The dam is now gone, and little evidence remains of any mills except this broken millstone. (Courtesy FHS.)

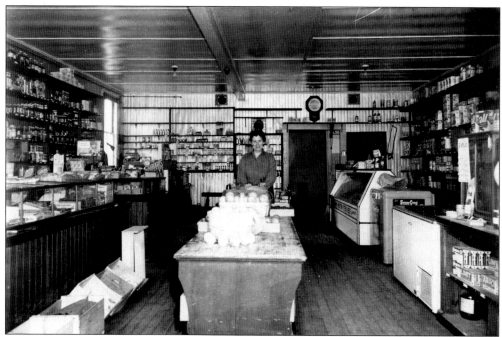

A landmark on Foreside Road for over 75 years, Dow and Hodgdon was a typical neighborhood store. The interior picture shows lines of shelves with cans and glass jars of food. The meat counter, cooler, and freezer are on the right. Mothers on the Foreside called and placed their orders with either William E. Dow (who was the selectman and ran the town) or Phil Hodgdon. The head orders were filled and delivered by 11:00 a.m. by Ray Ricker in the old pickup truck. A few years ago, the building was moved to the back of the lot. Originally of post and beam construction, it was rebuilt into an attractive, modern home. (Courtesy FHS.)

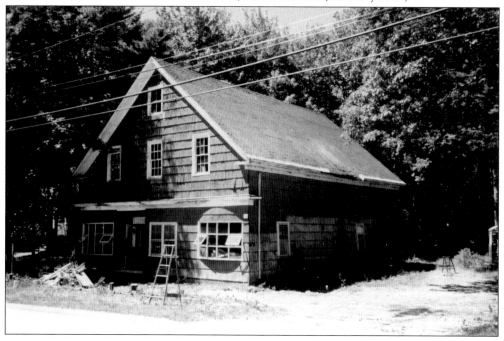

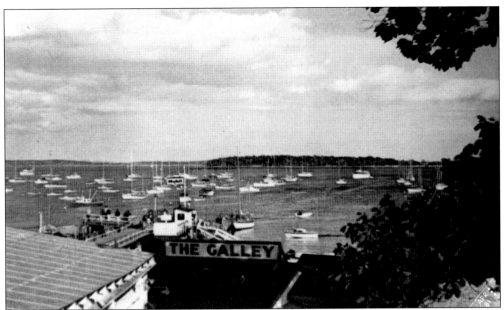

A 1950s hurricane destroyed the original wharf, the lobster shack, and docks at Handy Boat Service. Merle Hallet bought the service in the 1960s and has turned it into a first-class service for sail- and powerboats. There are 300 seasonal moorings and winter storage for 150 vessels. A 5,500-square-foot sail loft and a well-stocked chandlery make this a popular stop for cruising visitors. Handy Boat Service is a proud sponsor of the annual MS Regatta, which is the largest sailing race in Maine. It is a Gulf of Maine Ocean Racing Association–sanctioned scoring event and the largest charity sailing race in New England. (Courtesy FML.)

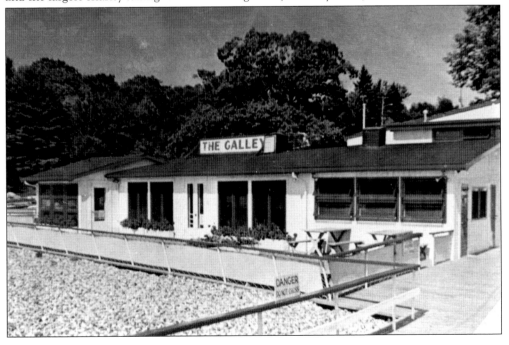

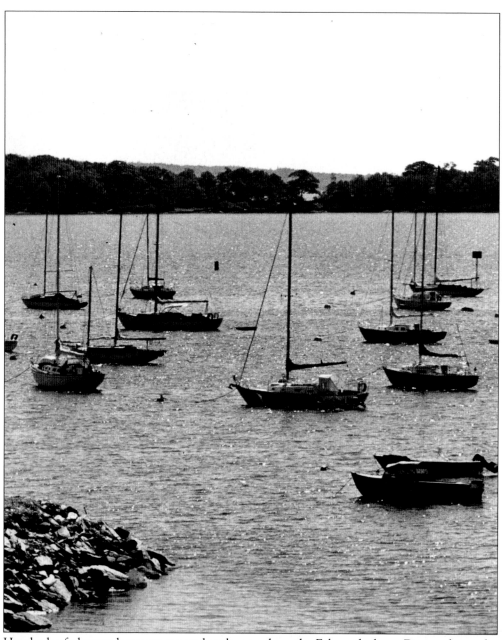

Hundreds of pleasure boats are moored each year along the Falmouth shore. During the cooler season, commercial firms care for some, while others, snugly covered, rest in backyards all over town. By June 1, a few hardy sailors place their crafts at mooring and go for a sail. The water is still cold, and the winds can be biting. However, by July 1, most boats are in the water ready to go. From then until Labor Day, Casco Bay is busy with boats of all types. Some of the larger-sized boats from other states come north to join local residents in sailing the waters off the Maine coast. Local sailors are on the water whenever they can take a day off, while visitors pray for a week of good weather while vacationing in Maine. All too soon, the season is over. It is then time to haul the old friend out of the water and prepare for another winter under cover. (Courtesy FHS.)

The photograph at right notes that as of December 9, 1946, the *Nellie G III* will winter on the Foreside. Dr. Walter Swett's new oak-built boat is a 54 foot diesel-powered craft that plies between Falmouth Foreside, Cousin's, Littlejohn's, and Great Chebeague Islands. The boat has a 25-passenger carrying capacity. Boats on the Maine coast are subject to the storms of winter and an occasional hurricane. Hundreds of boats are stored on shore each fall. Sometimes a storm hits before boats are stored safely. Such was the case in September 1954 when hurricanes Carol and Edna struck the New England coast within 12 days of one another. The Handy Boat Service yard lost its wharf and many boats. This luxury yacht was a victim. (Right, courtesy FML; below, courtesy Larry Shaw.)

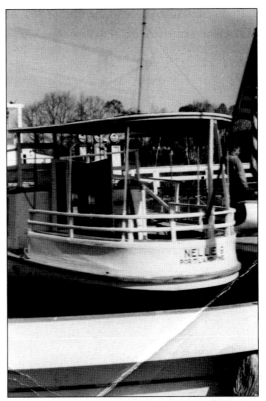

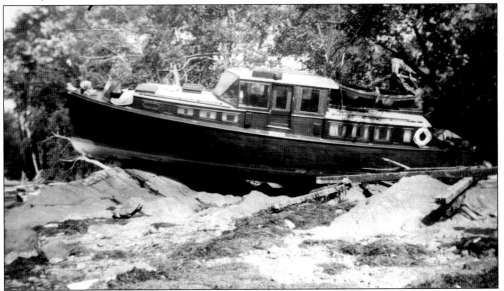

The Portland Yacht Club is the third-oldest continuously operating yacht club in the United States and the 13th in the world. Organized on April 26, 1869, the club has educational facilities for junior sailing lessons and boat docking. Weekly class races and the well-known Pilot and Monhegan races are standard fixtures of the club's schedule. A monthly newsletter written by the commodore keeps members informed about events in the world of yachting. A steam-powered electric generating plant was built in Falmouth on what is now Powerhouse Road to supply electric current to the trolley system. The Portland Yacht Club is now located on that site. (Above, courtesy FHS; below, courtesy F. L. Johnstone.)

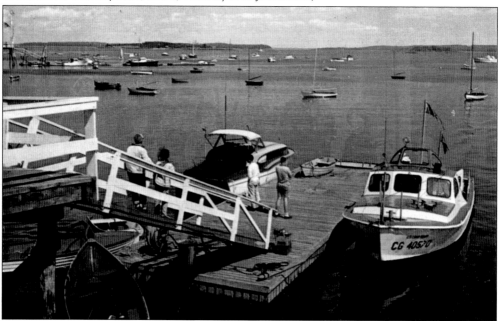

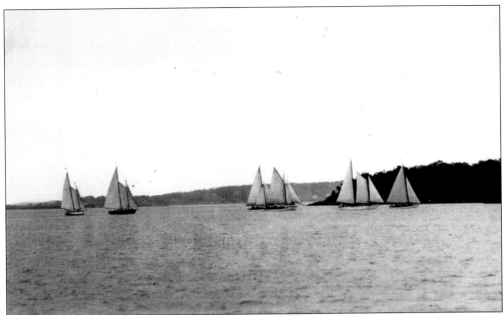

These bark rigged ships could be used for many purposes and were considered an excellent coastal vessel. They were relatively fast and required a very small crew to sail. Later some owners sailed them for pleasure since they were considerably less expensive than the huge sailboats vying for the America's Cup. Here are several, having a race off the Foreside. (Courtesy L. Snow)

Stepping Stones Country Day School is located next to Town Landing Market. Founded in 1949 by Virginia Cobb, it moved to its present location in 1962. Laura Bently purchased the school in 1972. Ann Parkhurst has been owner and operator since 1987. Classes are small, and the teachers are highly qualified. Many Falmouth adults who attended Stepping Stones are sending their preschool children to this educational facility. (Courtesy FHS.)

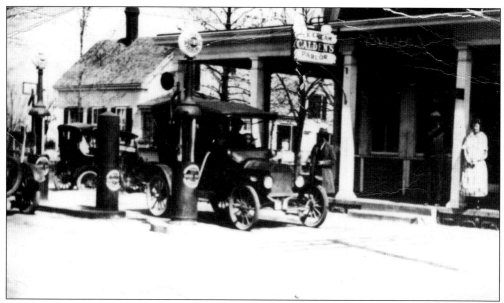

Over the past 125 years, the building housing the Town Landing Market has been a tearoom, a restaurant, an ice-cream parlor, and a gasoline station. The picture above, from about 1915, is of Calden's Ice Cream Parlor and gasoline station. The Ford Model Ts are gassing up with Socony gasoline. Socony was one of the 34 new companies formed when Standard Oil was dissolved in 1911. Now the building is a market continuing its long service to visiting boaters, tourists, and the neighborhood. The sign on the front of the store advertises "Fresh Native Ice Cubes," and it is famous for lobster rolls, sandwiches, chowder, fresh seafood, and many other favorites. (Courtesy FHS.)

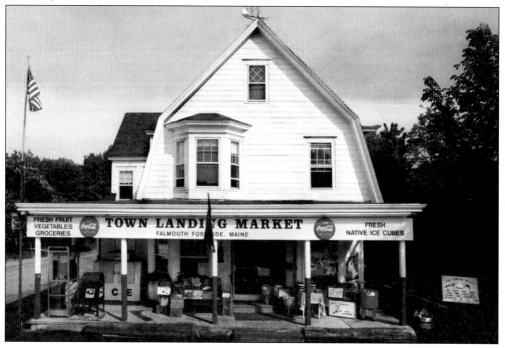

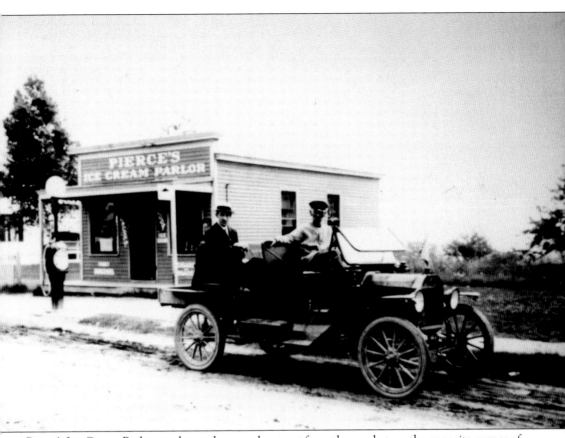

Pierce's Ice Cream Parlor was located across the street from the market on the opposite corner of Foreside Road. It offered free ice cream on opening day each year. Neighbors were always welcome as were those who stopped by on their way to Underwood Springs Park. This gentleman in his chauffeur-driven automobile is enjoying his cone. Most ice-cream parlors made their own flavors on the premises. It was a time-consuming process, and the usual motive power for turning the crank was human. Young people often took on this task with the promise that they could lick the ice creams off the beaters when it was finished. The most popular flavors were vanilla, chocolate, and strawberry. A good supply of ice was needed for the cream-making process, and another supply was needed to keep the cream solid once it had been made. In Maine, refrigeration and freezers were not the usual methods for keeping food until after World War II. However, Maine had an ample supply of ice. (Courtesy W. Pierce.)

This view of the Foreside shore was taken in the mid-1960s; many more boats now anchor here. On the left are the Handy Boat Service and the docks of the Portland Yacht Club. Close to the middle of the picture is the town landing. The little cove is the beach area of the once-famous Underwood Spring Trolley Park. In the far background are the White Mountains and New Hampshire. From 1941 to 1946, this view would have been completely different when Casco

Bay was the home of the Atlantic Fleet of the U.S. Navy. Ships of all sizes were crowded into the bay. In 1900, more open fields would have been visible. At that time, Falmouth had many farms producing hay, grain, and food for the two- and four-legged inhabitants of Portland. (Courtesy FML.)

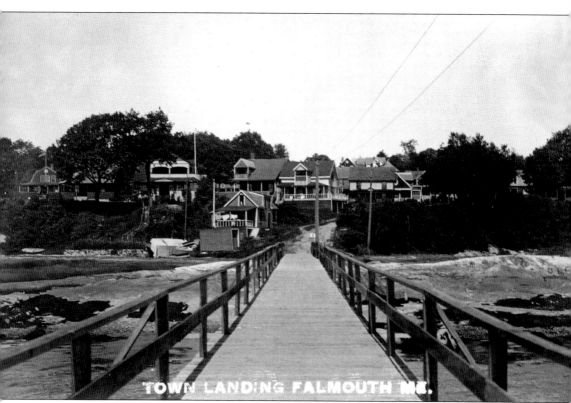

TOWN LANDING FALMOUTH ME.

Town landing is Falmouth's public place to land and launch boats on Casco Bay. This card tells much about life at an earlier time. The houses shown are summer homes usually owned by or rented to people from far away who want to enjoy the cool Maine breezes in summer. Full-time Falmouth residents lived on State Road (now Foreside Road), took care of the summer places, and supplied the summer folks with food and essentials. They looked upon Casco Bay as a means of livelihood rather than a place for recreational purposes. A camp on Highland Lake was better for swimming and boating. Since these earlier times, the recreational patterns have changed, and seagoing pleasure boats have become more available. During the warm months, hundreds of boats are moored here. A public beach is in the cove. Those who do not have boats often come here to see beautiful Casco Bay and enjoy the salt air. (Courtesy D. Merrill.)

Falmouth Foreside was a beautiful spot for vacationers. Families came year after year to the Casco Terrace Inn. Situated high on the hill, its terrace presented a beautiful panoramic scene of Casco Bay. All enjoyed the picnic grounds, play area, sandy beach, and the pier on the shore. The inn was just a block or so from the Underwood Spring Park. The automobile allowed tourists to become mobile and less inclined to stay in one place for weeks or months. Summer hotels became less popular, were neglected, and frequently burned to the ground. Casco Terrace Inn still stands as an apartment building. Seen below, these young men are having a parade at Casco Terrace. Their clothing indicates that this picture was taken about the time of World War I. (Courtesy FML.)

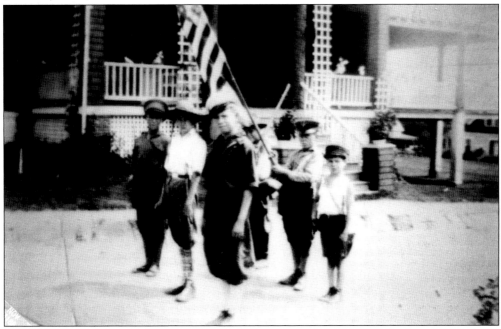

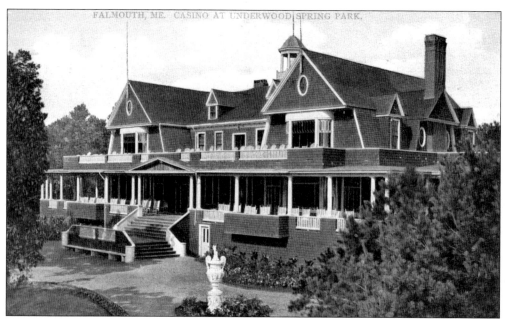

The Portland and Yarmouth Electric Railway ran tracks up Foreside Road to Cumberland, Yarmouth, and Brunswick. Service began on August 18, 1898, and the Underwood Spring Trolley Park opened on July 18, 1899. Similar trolley parks were opened at Riverton at Riverside Street and Forest Avenue in Portland and in Cape Elizabeth at Cape Cottage. In warmer weather, open-air cars brought people from Portland to enjoy the cooling seaside breezes. The casino was not a gambling place but rather a meeting, recreational, and eating facility. A fire in August 1907 destroyed the casino and theater and sent the park into a decline. The Japanese teahouse is on the shore. Tea was not served, but guests could sit and be surrounded by the ocean and enjoy the view and sea breezes while sipping Underwood Spring Water. (Courtesy FHS.)

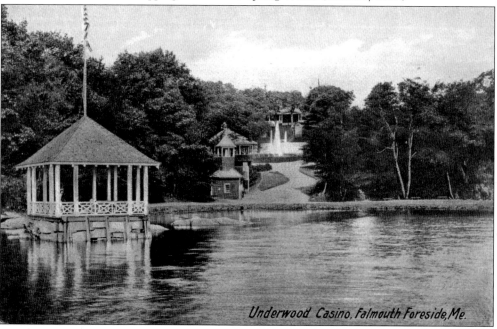

Underwood Casino, Falmouth Foreside, Me.

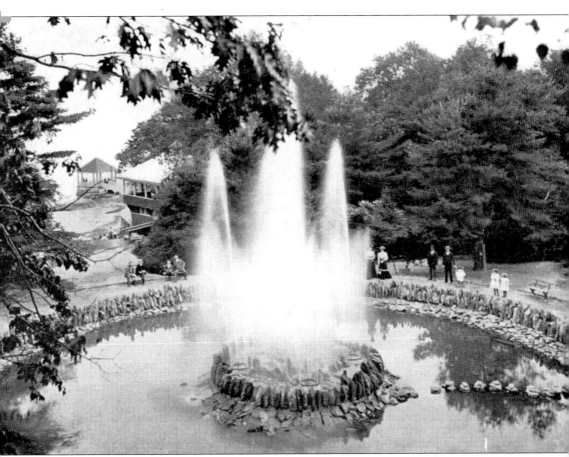

Colored lights around its base illuminated the fountain at night. It survived the fire that destroyed the Underwood Casino and Theater. Boaters remember when they could look toward the shore at night and use the fountain as a guide to the shore. The Underwood Spring is located near the shore. The water of the spring was said to be so pure and have so many healing ingredients that it could heal and cure many insidious diseases. The water was bottled and sold in plain, carbonated, and flavored forms throughout New England. Visitors to the Teahouse were supplied with free water. The spring was named for Capt. Joseph Underwood who was in Falmouth in 1790. It was used by Native Americans and was known to the very first local explorers and inhabitants. It is said to have produced thousands of gallons of water a day. The spring is still there, but little known and little used. (Courtesy FML.)

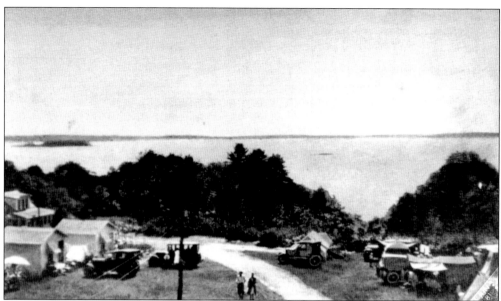

Shortly after the fire destroyed the Underwood Casino and Theater in August 1907, Russ Edwards, a local businessman, purchased the 37-acre park property. All of the other buildings and facilities remained. On the site of the former casino, Edwards built overnight cottages and a stage for the theater. Visitors could still go to the beach, the spring, the dock, and the teahouse. The lovely groves of trees and beautiful views of Casco Bay were still the same. Bottles of Underwood Springs water were available and widely used in the area. The Underwood Theater attracted professional entertainers and drew tourists and local Foreside residents. Local people were asked numerous times to audition for the professional actors and directors who came to entertain the guests at the camp. The Underwood Motor Camp continued until the 1930s when Edwards died. (Courtesy FML.)

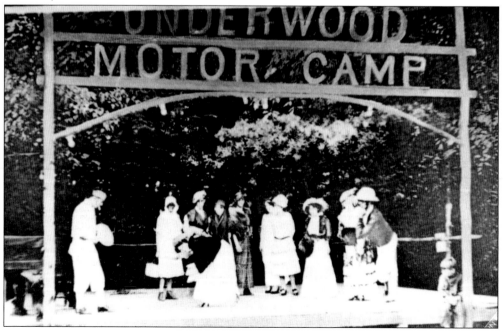

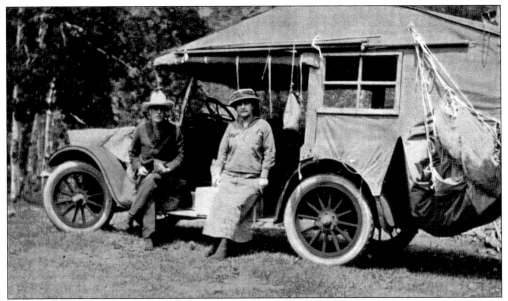

Many vacationers came to the Underwood Motor Camp. There were some structures on the property that were used as cabins, some visitors brought tents and camped out, and still others made living quarters by draping canvass around their automobiles. Some inventive travelers constructed motor homes as shown in this pre–World War I scene of two proud campers who have "just rolled in." (Courtesy FML.)

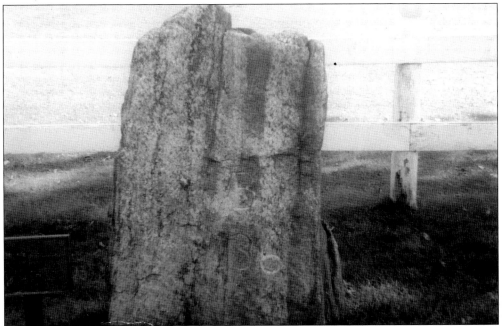

The King's Highway connected towns along the coast of Maine. The highway's construction, authorized by the government, ran along the shore but went inland around Casco Bay. In 1761, it was upgraded to a military road. Road marker stones were not found here in Falmouth, but this marker in the town of Cumberland indicates that Boston is 136 miles from there. (Courtesy FHS.)

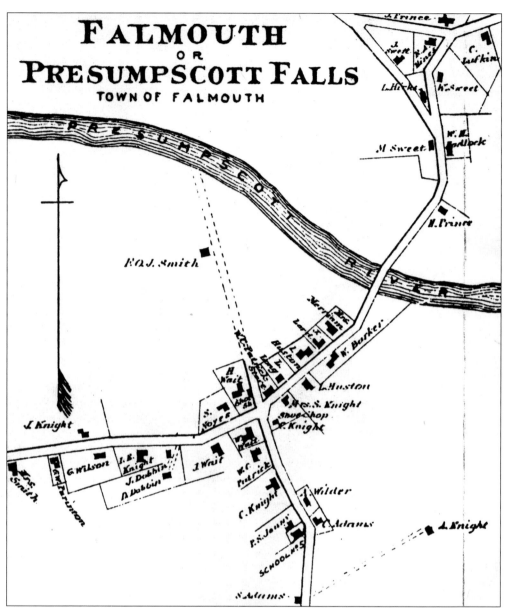

This 1871 map shows the village of Presumpscot Falls located near the lower falls on the river. In the 1600s, those who first settled were aware of the potential for a reliable source of waterpower and suitable locations for mills. It was here on the east side of the river's estuary that Arthur Mackworth settled in 1632. In the next 20 years, he was followed by James Andrews, Nathanial Wharff, George Felt, Francis Neal, Jenkin Williams, John Wakely, and Humphrey Durham. On the west side, Robert and John Nicholson, Robert Greason, and John Phillips came before 1657. After 1719, with the second creation of the town of Falmouth and the diminishing of hostilities with Native Americans, settlers began to return. In 1871, the area had a post office, stores, a school, a place of worship, a community building, and numerous mills, shipyards, and industries along the river and most importantly a bridge. As the population increased, houses were built up the hills from the river until it became a village, as seen in this map. (Courtesy FHS.)

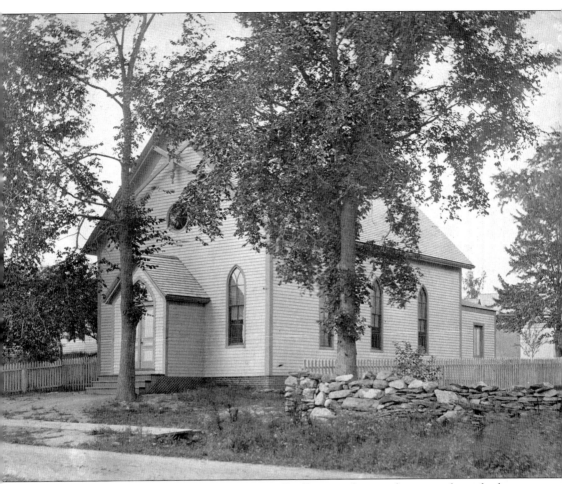

During the last half of the 1800s, the Pleasant Hill village was busy and growing, but it had no church or community building. Susan White donated land at Allen Avenue and Pleasant Hill Road for a chapel in 1878. The funds for the building came from suppers, glees, musicals, minstrel shows, ice-cream socials, and other community efforts. All these efforts were under the guidance of the Pleasant Hill Chapel Association. However, gambling and dancing were not included. Whist parties and dancing were held in the Union Hall that is now the No. 3 fire barn. The chapel held annual Christmas pageants, and a women's group and the Girl Scouts met there. Regular Sunday school services were held there into the 1940s. In 1977, Howard and Louise Reiche purchased the chapel from the First Baptist Church. The chapel has been the setting for many family celebrations. In 1999, Louise Reiche was given the award for stewardship of historic property by Greater Portland Landmarks in recognition for her restoration and maintenance of the Pleasant Hill Chapel. (Courtesy Reiche family.)

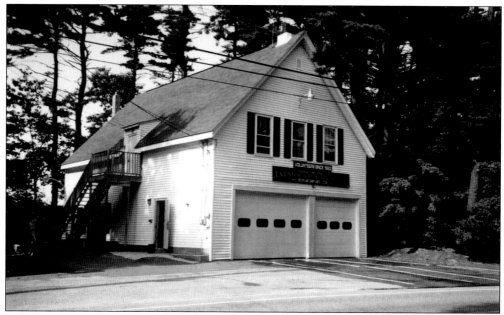

From 1874 to 1884, a group of neighbors in the Presumpscot Falls (Pleasant Hill) area joined together to build Union Hall. The interest and money gave out before it was finished, but it was used for many years for events like shows, operettas, parties, dances, and scout meetings. By 1923, the building needed repairs. The town assumed ownership and made it a fire station with a community room upstairs. (Courtesy FHS.)

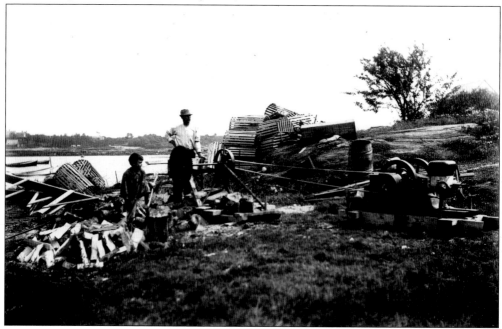

Within the past few years, lobstering has followed the trend to plastics, and lobster pots or traps are mostly made of plastic. This turn-of-the-century craftsman and his helper have made a supply of pots and is now cutting stove wood. The one-cylinder engine provides power for the saw. The same type of engine could be adapted for use in boats. (Courtesy FHS.)

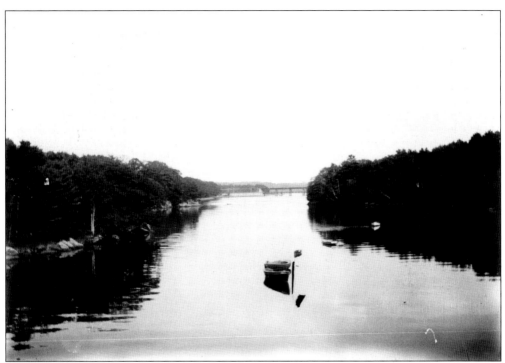

A single boat moored at midstream hardly portrays this busy river 200 years ago. Shipyards on the Presumpscot River and the estuary produced over 100 ships from the 1780s through the early 1900s. These ranged from small coastal craft to many three-masted seagoing vessels. Wood for building hulls was cured for several years before being used. Poles for masts were used as soon as possible after cutting to retain the flexibility needed for the movement of the sails. A ship was built on a way in a supporting cradle to keep it upright. At launching, the way was greased and the restraining blocks removed. If successful, the ship slid down and floated upright. It was then moved downriver at high tide to a holding pool where the superstructure and masts were added. (Courtesy FHS.)

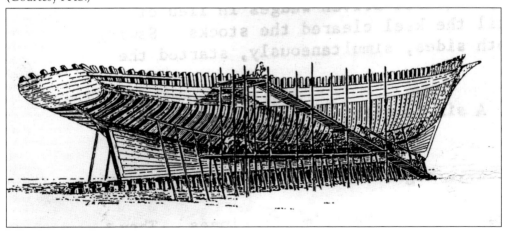

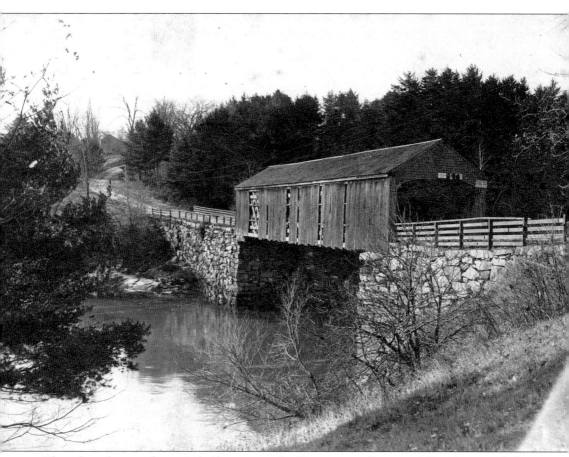

There have been at least six bridges across the Presumpscot River at Allen Avenue. A ferry crossed the river in the early days. Each bridge was built higher above the water than the one before. The first bridge was built in 1728. As an open bridge, it did not fare well because of the weather, ice, and high waters. By 1747, a new bridge was needed badly. A petition to the town was rejected. The Massachusetts General Court declined, and the general assembly in Massachusetts also declined but gave the town permission to raise the money by lottery. A new bridge was built, but it too was gone within a few years. Bridges were constructed by local people using the tools and resources available locally. In all, four covered bridges were built. The final covered bridge, shown here, lasted until the advent of the automobile. It was repaired and rebuilt several times. The openings are designed to allow some snow to enter for sleighs in the winter. (Courtesy FHS.)

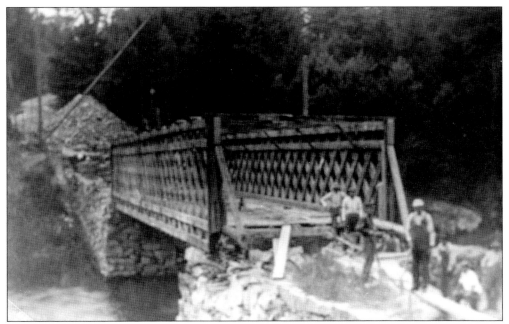

As the old bridge was taken down, workers saved all usable materials. The tall man in the foreground is Bill Harden, who had a farm on Schoolhouse Lane. The construction of the new bridge in 1911 across the Presumpscot River at Allen Avenue Extension was a new experience for the town. In the past, bridges were built by local people. For the first time, a professional engineer and a state inspector were involved in the planning and construction of the new bridge. The state was building a bridge made of concrete and steel that was to last 100 years. Engineers and specialists from out of state were involved for the first time. This bridge was built higher than previous bridges thereby reducing the hill to be climbed at each end. It was the longest single-span concrete bridge in Maine. (Courtesy FHS.)

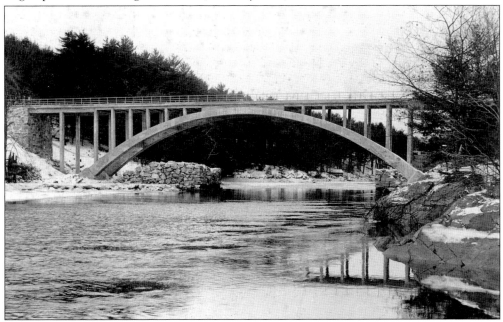

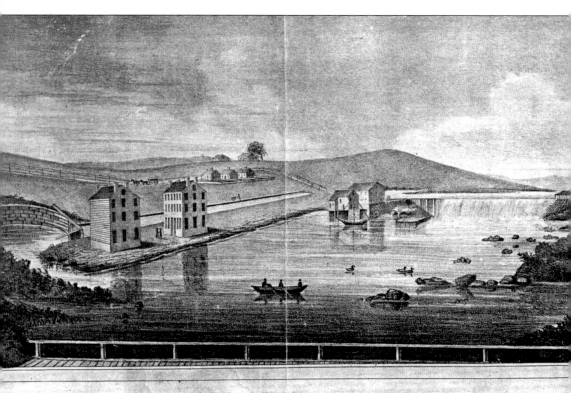

PRESUMPSCOT LOWER FALLS.

This drawing appeared in the 1880 *History of Cumberland County, Maine*. There was a dam here as early as 1735. When early explorers sailed along the Maine coast, they went up every river looking for the Northwest Passage and for treasures of gold and silver. After entering the wide Presumpscot estuary and then the river, it was a disappointment to find that it was a tidal river not navigable beyond the lower falls. Little did they realize that in the future the shores would be lined with mills and shipyards. At one time, there were mill operations for grinding grain, sawing wood, making silk, cutting shingles, and making wire. There was even a brickyard. Rights to build were granted from Boston to each person seeking to establish a mill, shipyard, or manufactory. People with experience in these fields were among those who established such enterprises. They had no indication at first of the strong winter storms and the heavy ice flow in the early spring months that could destroy their buildings. (Courtesy FHS.)

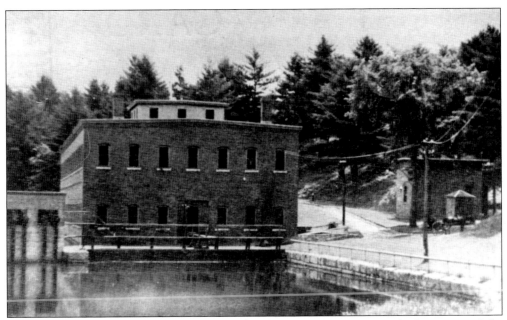

The Smelt Hill power station was a boon to the employment situation in the later years of the 19th century. Intelligent young men who desired to avoid the repetitive work of mill employment were trained for work with the first electric power station in Maine. The station was built by the S. D. Warren Company to supply electric power to its paper mill in Westbrook several miles away. Members of this work crew were Harry McCann, Elmer Cleaves, Arthur Blake, and other unidentified people. The station began operation in 1889 and was one of the first in the country. A dam was built in connection with the station. However, continuing problems with ice in the winter finally resulted in a complete shutdown of the system. The larger station building was razed, and the dam itself was removed in 2001. The smelt is a small, silvery salt- and freshwater fish. In the early years, millions of these fish were taken in weirs to supply needed food to both Native Americans and settlers. (Above, courtesy FML; below, courtesy Wheeler family.)

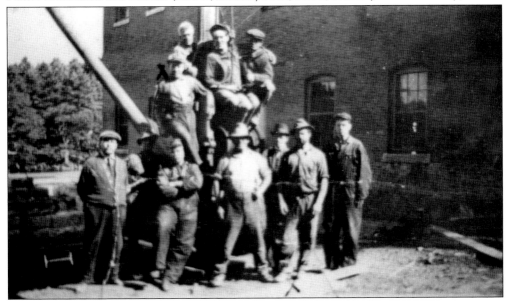

Mills did not run year after year without maintenance and much of this consisted of keeping the scuppers or paddles free of debris that came down the river. One method used a floating walkway to keep surface debris from the intakes. Ice in the winter and high water in the spring were often times of great difficulties for mills. The picture below of the Smelt Hill Dam shows the problem that can occur after a few days of zero weather. Ice was bad enough when it froze solid, but when a warm spell began the breakup, real damage could be done. The Smelt Hill power plant was eventually closed because of serious damage by ice. (Courtesy FML.)

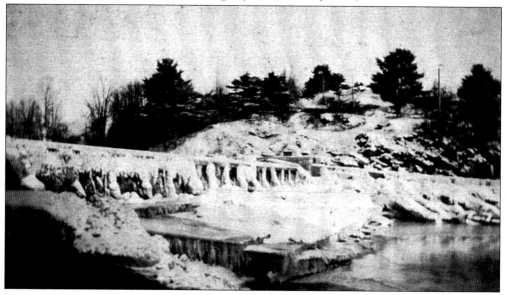

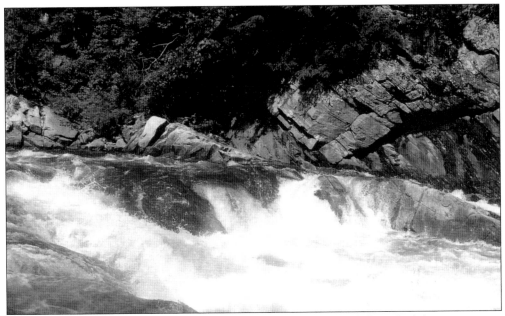

These recent photographs are of the Presumpscot River. Few people have had the opportunity to see this section of the river. It must have looked like this before the Smelt Hill dam was built in 1889. This wild, rugged, and isolated stretch of the river is only a few blocks from more civilized areas of Falmouth. The height of the dam changed the nature of the river and allowed small steam and motor launches to navigate this area. The first dam at Smelt Hill falls was built about 1735 by Col. Thomas Westbrook and was Maine's first dam. The Presumpscot River starts at Sebago Lake and flows for over 25 miles to Casco Bay. It drops 270 feet in that distance and has at least 12 falls. Smelt Hill falls dam and the power-generating system were damaged in 1996. The dam and buildings were removed in 2001. Nine dams remain on the river. (Courtesy R. O'Donnell.)

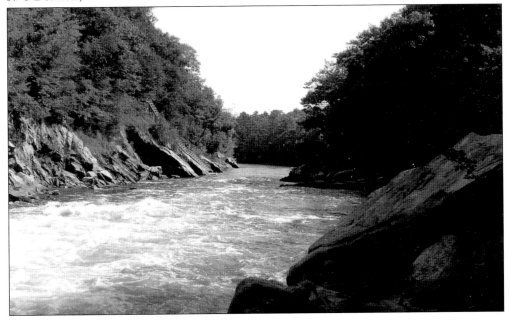

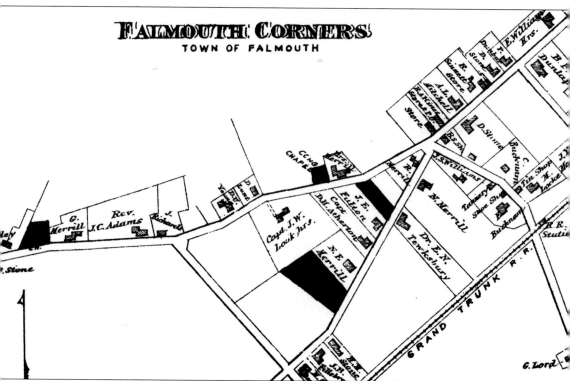

The Grand Trunk Railway published descriptions of the many towns that it served. The clipping for Falmouth stated, "Falmouth, a station on the Grand Trunk Railroad five and one half miles from Portland, comprises 30 dwellings, the church and chapel of the First Congregational Parish, schoolhouse, the abandoned Academy building and the following business interests: grocery and provision store Perry & Rose, established by Abner S. Perry at the old stand of Albert A. Mitchell in 1876; custom shoe shop, A. O. Miller 1875; tin ware manufactory, and peddlers supply shop, M.S. Locke established 1858; wagons Samuel H. Anderson established 1868; blacksmithing; George W. Merrill established 1878; brickyard James Lucas; painter L. O. Bean established 1871; general mason Charles B. Husted; Lucian Ingalla, Postmaster. Mails received daily by rail." This listing may go beyond the immediate area of Falmouth Corners. (Courtesy FHS.)

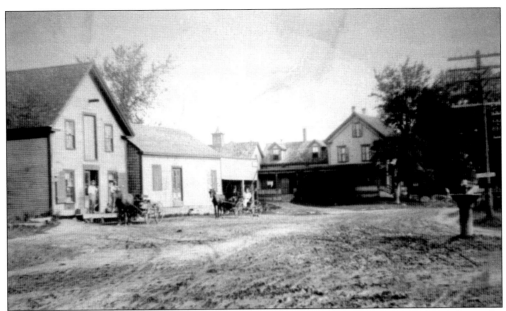

These two pictures of Falmouth Corners were taken some years apart. The one above shows the Dresser and Carlisle Store, which carried any item one might need. It was the major local store and place to catch up on the news. The building is still there, although it has been altered after 120 years. Other stores may be seen farther along on Middle Road. The watering trough for the horses has been moved to the side of the road. On the right, Depot Road, now Bucknam Road, goes to the railroad station. The newer picture shows that some customers came by horse and wagon while others came by automobile, and ownership of the store had changed. It became known as Robinson-Perry's Market, but it still offered needed items and a chance to catch up on the news. (Above, courtesy FML; below, courtesy FHS.)

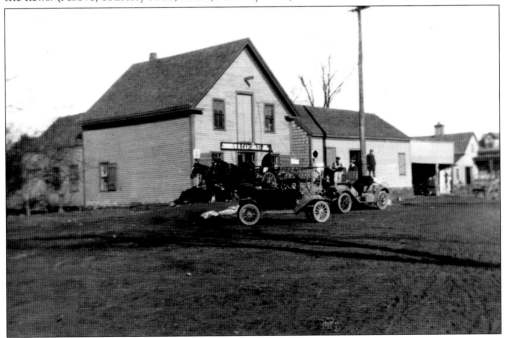

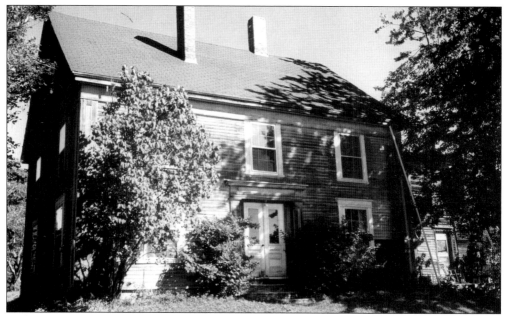

Bucknam's Tavern was a stop on the stage route between Portsmouth, New Hampshire, and Bangor, operating on the King's Highway (Middle Road). Built in 1776, its first owner was Samuel Bucknam. The house is still owned by family members. Weather and road conditions had a great impact on travel. It is estimated that in Maine in 1826, stagecoach speeds averaged four miles per hour. Stage stops were usually nine miles apart. (Courtesy FHS.)

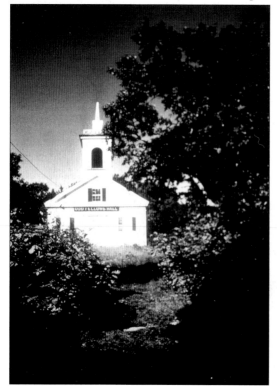

Henry Merrill, former superintendant of schools, wrote that the academy was built in 1833 on the farm of Rev. David McGregor on the Falmouth Road. He taught there several years, and on his death, it was taken over by several teachers, moved to its present location, and named the Oak Grove Academy. Abandoned, it was later purchased by the Independent Order of Odd Fellows (IOOF) and restored. The grounds are entered from Lunt Road. (Courtesy FHS.)

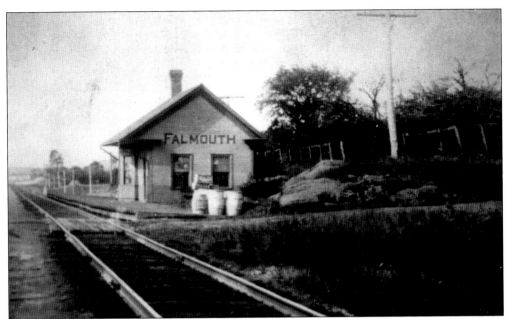

The Grand Trunk Railway was located on Depot Road. From the 1880s through about 1900, summer visitors arrived for the season. This included adults, children, pets, servants, and considerable luggage. Fathers came up every weekend and the last two weeks of summer. Eager young boys met trains with their wagons, hoping to make money carrying luggage and sometimes children and pets to hotels and cottages. (Courtesy FHS.)

As settlers returned after 1715 to areas formerly occupied, plans were made to assign one or more woodlots to each landowner, and to the church, the minister, and the school. Woods Road in Falmouth was designed for this purpose. It was isolated and not populated. Wood was cut and stacked for heating and for cooking. A family-owned woodlot, carefully tended, provided a continuing supply of wood. (Courtesy FHS.)

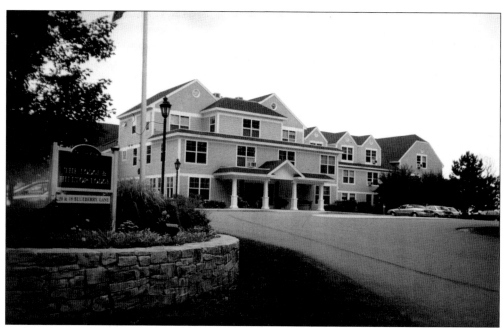

Ocean View, an attractive retirement community, was established in 1988. Situated on a hill overlooking the Presumpscot River estuary, the campus of Ocean View has attracted many local and out-of-state retirees. Residents often come from other states to be near families residing locally. Situated on ground between Falmouth Road and Middle Road, its main street is Blueberry Lane. Comfortable accommodations are found in the apartments at Hilltop Lodge as well as in the many cottages. The Falmouth House provides assisted living care to other members of the Ocean View community. Through the generosity of John Wasileski, owner of Ocean View, the Falmouth Historical Society has its offices and reference services in the historic Whipple Farm House. (Courtesy FHS.)

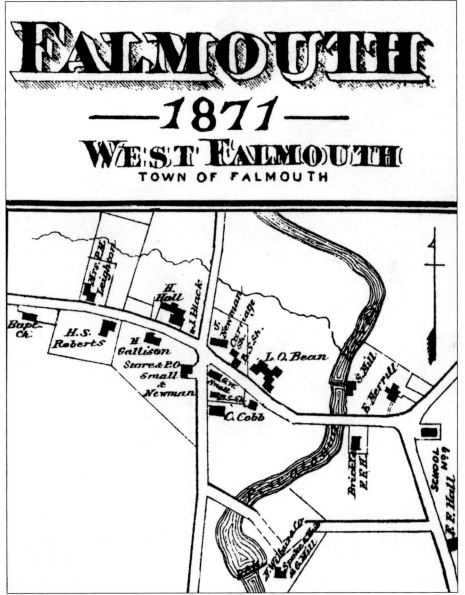

By 1871, West Falmouth was a thriving village. It had schools, a church, stores, a blacksmith, two mills, manufacturing companies, and its own post office. It grew around the crossroad where the modern Gray Road intersects Mountain and Falmouth Roads. Early stage routes came through West Falmouth, as did the railroad and the trolley line to Auburn and Lewiston later. Blackstrap Hill was renamed Independence Mountain around 1850, and entrepreneurs built what came to be known as Blackstrap Observation Tower. Their ambitious plans to build a hotel nearby never materialized. The view from the tower was said to be awesome. Local residents are intrigued by the name Blackstrap Hill. Several explanations are given for its name, including that it appeared as if there were black straps on the hillside visible from a distance, or that it was because of the rum drink with blackstrap molasses served at Lambert Tavern. At one time, there was the Wilson Tavern on Blackstrap Road near the top of the hill, and the Lambert Tavern was at the bottom near the Presumpscot River. (Courtesy FHS.)

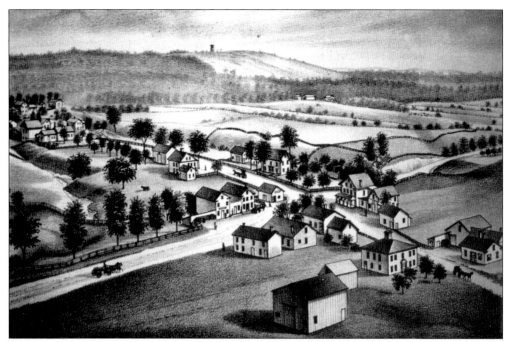

These two images give a good view of West Falmouth. This sketch from about 1870 looks directly toward the intersection of Mountain Road, Main Street (Gray Road), and Falmouth Road. To the upper right is West Cumberland and then Gray. To the lower right is Falmouth Road. In the middle toward the top of Independence Mountain is the Blackstrap Tower. Mountain Road goes to the tower. The postcard picture was taken from the intersection of Mountain and Gray Roads looking toward the Presumpscot River and Portland. On the right is the Arthur Noyes Store. The second floor of that building housed the Piscataqua Library, with 530 volumes. (Courtesy FHS.)

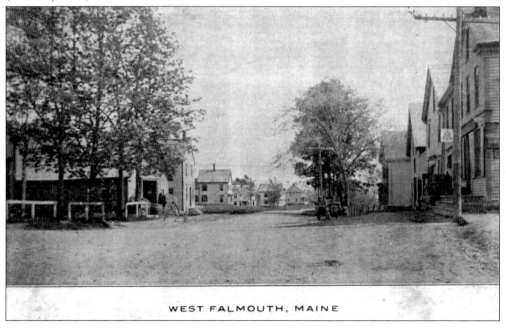

WEST FALMOUTH, MAINE

The West Falmouth Grange and the Knights of Pythias hall on Falmouth Road are located near the intersection of Main Street and Falmouth Road. The Grange was the main social focus of an agricultural area like West Falmouth. Meetings, dances, and suppers were held here. Rooms were rented to other organizations. Young people would meet here for after-school activities. A Grange store was in an adjacent building. (Courtesy McCann family.)

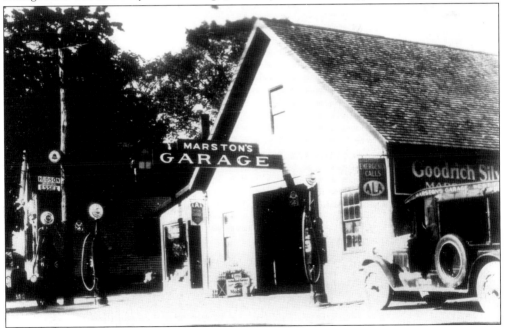

Marston's Garage, shown here in 1936, was owned by Harold Marston. Marston was a direct descendent of Benjamin Marston, who settled in West Falmouth in the late 1700s. The garage, once a blacksmith shop, sold gasoline and made automobile repairs. The garage is no longer there, but the house next door where he lived is. (Courtesy Winslow family.)

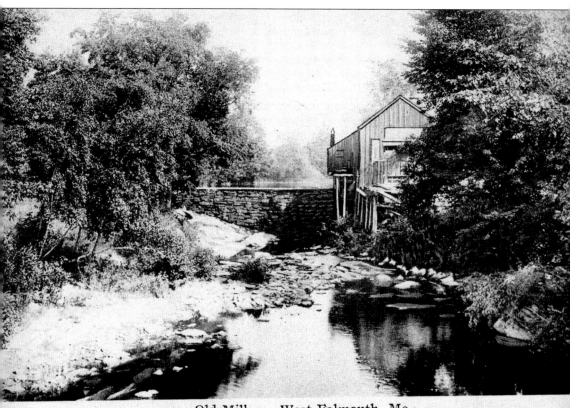

Old Mill, West Falmouth, Me.

This was one of the last operating mills in West Falmouth. Its picturesque setting made it a favorite for photographers and postcard makers. The Kodak box camera and roll film made photography easier and more popular. The Piscataqua River was ideal for small mills. Small dams could be built, and except for an occasional dry period, the river provided enough water to turn the wheels. The larger mills directed water through a millrace to the top of the overshot wheel. The water tumbling down on to the scupper provided the weight to turn the wheel and provide power. The scuppers required more work to build a wheel and more work in maintenance. This postcard picture is an example of the many small mills and factories that grew up along the Piscataqua River. Before the advent of electric power, the river was a most important and vital element in providing needed products as well as employment. The milldam was destroyed by ice in 1930. (Courtesy FHS.)

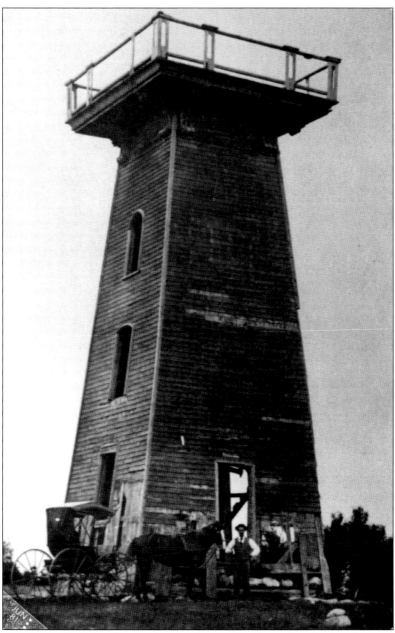

Samuel S. Webster built a wooden tower on Blackstrap Hill in 1852. He owned much land on the hill and hoped to acquire a fortune by charging admission to the tower. A telescope was an added attraction. The anticipated fortune did not materialize, and in 1855, he sold the tower to Dependence H. Furbish of Portland, who renamed it Independence Mountain. The tower was closed to the public. The property was owned later by several other people and may have been opened at some point. It had deteriorated severely before it was toppled by high winds in 1909. The top of the tower was 545 feet above sea level. Even when closed, sightseers came to enjoy the excellent views of the White Mountains to the west and Casco Bay to the east. It was a landmark for ships entering the Portland Harbor and an important watch location to warn the neighbors of possible fire danger. (Courtesy FHS.)

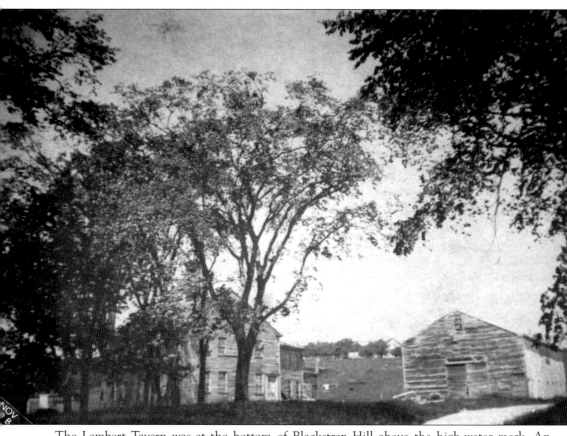

The Lambert Tavern was at the bottom of Blackstrap Hill above the high-water mark. An electric transformer is there now. An original, open one-lane bridge across the Presumpscot River connected Lambert Street in Portland with Blackstrap Road. It was replaced by a covered bridge. Later it was renamed the Lambert Bridge. It was said to be of poor appearance even when it was new. The bridge burned down shortly after the Blackstrap Tower was opened in 1853. The tavern had a room for locals and travelers and several rooms for overnight stage riders and the overflow from nearby taverns. It was well known for an unusual drink served in a tin cup that contained rum and a generous dollop of Blackstrap Molasses, and for some, an added dollop of cream. Imbibers joked that no one knew whether the drink was named for Blackstrap Hill or the hill was named for the drink. Winslow Corner is just up the road at the crossing with Brook Road. (Courtesy FHS.)

Old Quaker Tavern is on the Gray Road. It was known as the Falmouth Tavern for many years. After an amazing restoration, it is back to its simple beauty. Now a bed and breakfast, it allows guests to step back in time when they stop for a night or longer. When guided through the house by the hostess, much history is learned. (Courtesy D. Little.)

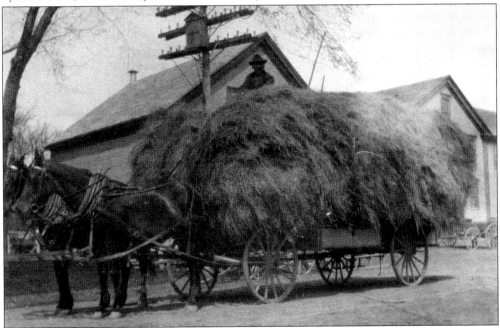

Cornelius Ross stands proudly on top of this extremely high hay wagon. He may have beaten an oncoming storm, or perhaps this was the last cutting of the season. With his trusted helpers, he will get it all in Grace Huston's barn before dark. This much hay will be removed carefully and restacked to dry under cover. (Courtesy FHS.)

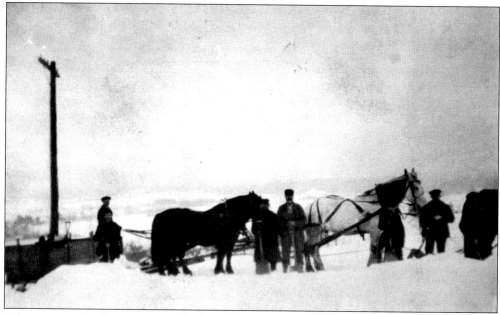

When snow arrived in winter, a vehicle with runners was the preferred form of transportation. A firm base of packed snow was the best of all possible roads for a horse and sleigh, as no plowing was done. This wagon may conceal a heavy roller, which packs down the snow. Seen above on Brook Road near Leighton Road in 1920 are, from left to right, S. G. Huston (driving), Stephen O'Brien, Ellery Huston, Harly Winn, Lloyd O'Brien, and an unidentified helper posing with their snow shovels. Out on the farm, oxen were preferred for heavy duty plowing of the rocky Maine soil. Spike Marston used his prize-winning oxen to plow his fields. As people passed by, they stopped to watch Marston and his oxen. (Above, courtesy McCann family; below, courtesy E. Winslow.)

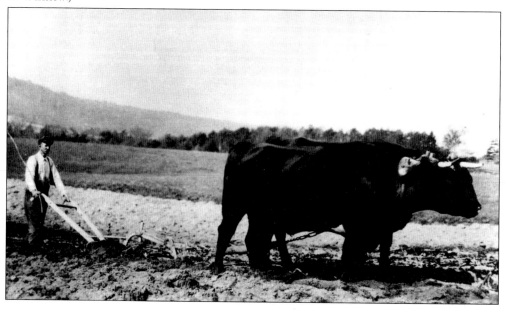

The community was run by elected selectmen, and the town house was the focus for town business. People were appointed to police and oversee most of the important daily activities that dealt with business transactions. Town meetings were held each year. At the Falmouth town meeting of 1850, the town house was spoken of "as black and weather beaten and badly in need of repairs," Each year, some voters tried to build a new town house, but it was not until 1890 that enough agreed to construct it and 1903 before enough funds were available to complete it. A room for a high school was added on the first floor. In 1963, there was a complete renovation, and the building became the town office. The old town house was sold for $12 to Graham Whitney and moved by two yolks of oxen to his farm across the road. (Courtesy FHS.)

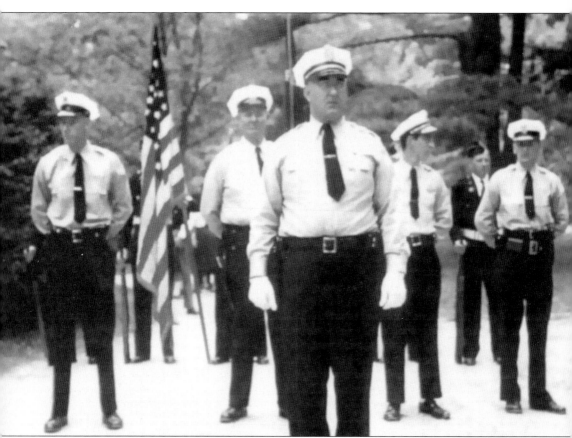

Pictured from left to right are unidentified, Paul Lalumiere, Ray Marshall, Rodney James, and Bennie Carr. Roland Moore is marching with the legion members in back of the police officers. In a commentary on crime, Mel Allen, a noted sportscaster, said, "Here is the problem, while there are small towns and small town police departments, there is no longer any such thing as a small town criminal." Falmouth has responded to this national trend and made sure that it has one of the best trained and equipped forces in the state. When called upon, their response is prompt and efficient. A constable provided police services in earlier days, and then there were two constables and some police volunteers. These people served on a volunteer basis with little compensation except for expenses incurred. In 1953, a two-way radio was installed in the constable car. Now there is a fully trained force of officers with many having attended Maine Criminal Justice Academy. (Courtesy FHS.)

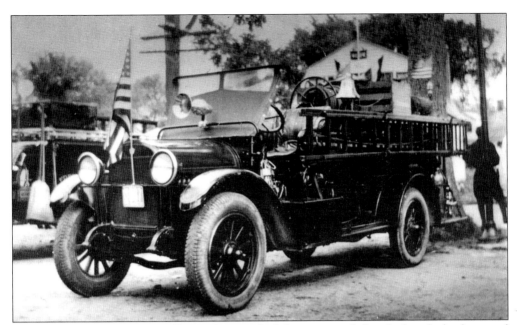

There was a time when the gallant volunteer firefighters responded with shovels, buckets, and hand pumps. Now they are well trained, better equipped, and able to respond much more quickly. Each volunteer has his own protective clothing with him for prompt use at a fire. Training sessions are held each week at the main fire station. Pictured above is the town's 1925 Reo fire engine. On a Sunday afternoon in April 1925, a passerby took the picture below of the Falmouth Fire Department trying to save the ancestral home of the Leighton family on Leighton Road. The old equipment truck and the firefighters were working in the rain. In spite of their efforts, the house was badly damaged. In the late 1960s, fire departments in this state were eager to acquire a new type of vehicle to provide mobile emergency medical services. Falmouth has a well trained and equipped emergency medical service that is a part of the 911 system. (Above, courtesy FHS; below, courtesy Don Leighton.)

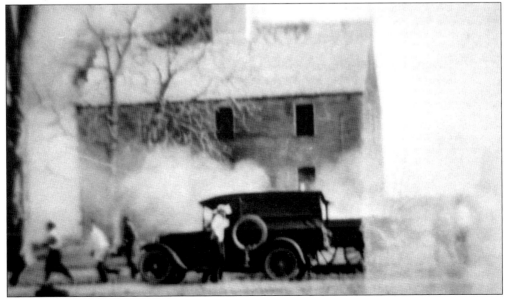

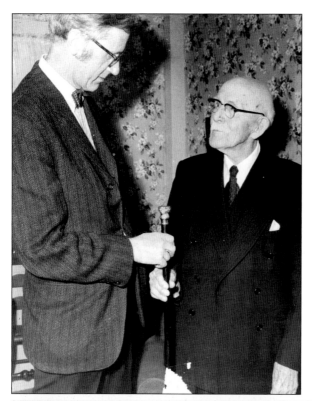

In 1909, the *Boston Post* newspaper gave 431 gold-headed canes to the towns they served. Each cane was to be presented to the town's oldest citizen with a lapel pin and a certificate. Recipients were to keep the pin and certificate but return the cane to the town. In Falmouth, the cane is on display at the town office with details of the award. On the left, Roger Snow is shown presenting the Boston Post gold-headed cane to Reuben Merrill in 1973. Merrill was 95 years old, the town's oldest citizen. Below, on the right, Ted Vail is shown presenting the cane to Arthur Lawson on his 99th birthday in January 1995. (Courtesy FHS.)

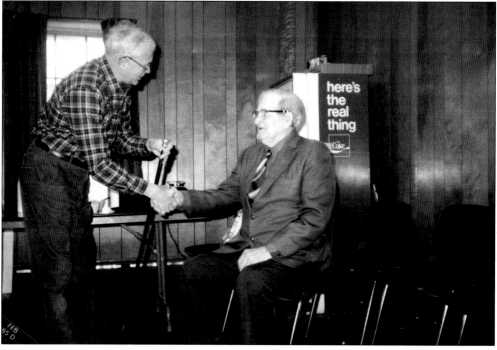

Three

HOMES, CHURCHES, AND SCHOOLS

The majority of older, larger houses in Falmouth are rectangular with a middle door and five to nine windows on the front. Most were farmhouses with attached outbuildings and barns. This style has continued in many of the new houses. There are many older, smaller homes of the cape style.

Although there was the Merrill brickyard along the Presumpscot River, there are few brick houses or buildings in town. Rebuilding Portland after the great fire of 1866 may have taken most of the yards' output for many years.

The older houses in Falmouth were perhaps of simpler designs than similar-sized homes in other seaside towns. The New Casco area was rural and was not called affluent. People who made a living in the shipping, commercial, and manufacturing areas tended to concentrate in the Portland area. Often their homes reflected their status in the community. After the Civil War, as land was acquired along the shore for estates, the houses were designed by architects whose creations reflected the wealth and status of their owners. When an unusual house did appear, it was usually built by someone who had made money elsewhere.

In Colonial days, the Congregational church was the only one in most towns. Citizens of the town supported the church with tax money. After the American Revolution, the idea of the separation of church and state appealed to those who wished to form and attend services other than those at the Congregational church. Baptist churches came early to Maine, as did the Methodist and Quakers. The Roman Catholic, Episcopal, and Lutheran churches came later.

Prior to 1931, with the opening of the Falmouth High School, students graduated from the eighth grade. If they wished to go on to high school, the town paid their tuition to schools in Portland or to a town with a high school.

At one time, there were at least 10 grade schools, including Pine Grove, Underwood, Lunt, Graves, Piscataqua-Huston, Barker, Winslow Corner, Woodville, Blackstrap, and Hurricane. Many had only one room. The children walked to the nearest school.

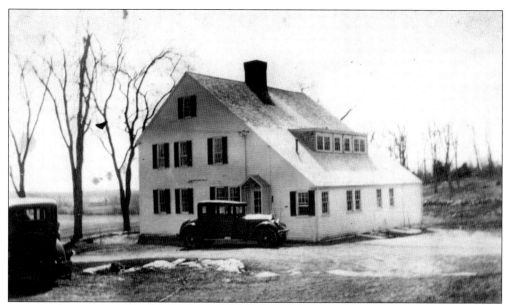

It is fitting that the home of the Falmouth Historical Society, the Whipple Farm House, is presented first. Before it was called the Whipple House, it was known as the Pettengill place. However, this was one of Falmouth's Merrill houses. Joshua Merrill, the son of James Merrill, built this house soon after his marriage to Mary Winslow in 1755. They lived there for 27 years. Joshua's niece Mary Merrill and her husband, Benjamin Pettengill, who were married in 1783, purchased the house. From account books and iron tools found, it seems that Pettengill was a blacksmith. Around 1930, Mr. and Mrs. Whipple purchased the estate and restored it. The living room fireplace (one of five) is huge, as that room was the original kitchen. There were other owners after the Whipple family. (Courtesy FHS.)

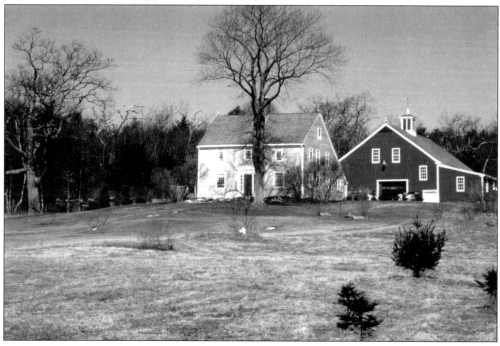

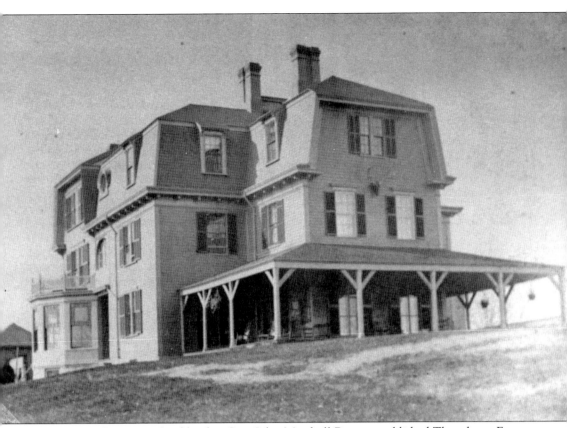

After the Civil War, Portland banker Gen. John Marshall Brown established Thornhurst Farm on a narrow point of land between two coves. Thornhurst Road gave access to the property. Brown hired the well-known Portland architect John Calvin Stevens to design an imposing 22-room summer cottage. This was a gentleman's farm. The farm maintained a herd of Jersey cows, many owned by other people. The milk from each family's cows was delivered to that family. Brown was part of the local group importing Jersey cows to the area. By 1952, Brown heir Herbert Payson and his wife determined that the house was too difficult to maintain. They had the mansion torn down and replaced with a modern one-story house. The stables were converted into a house. The eight-sided teahouse also designed by Stevens still stands on the water's edge. Brown donated land from his holdings at Thornhurst Farm and built the Church of St. Mary the Virgin on Foreside Road. (Courtesy FML.)

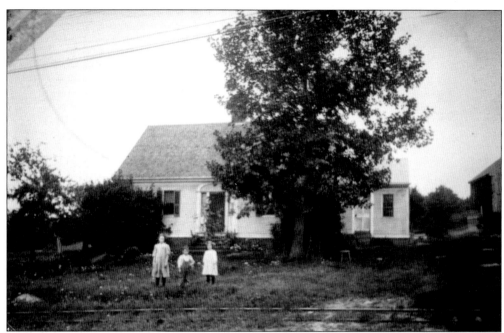

Both of these houses are on Foreside Road within walking distance of each other. Each is cape style. The upper picture of the house at 154 Foreside Road shows the tracks of the trolley from Portland that ran in front of the house. Watching and waiting for the car to pass was probably entertainment for the children. The house in the lower picture at 168 Foreside Road was built around 1758. This was the home of Mary and John Morris. Family members still live here. Herbert J. Brown once owned much of the land behind the house. Brown's family gave 35 acres in his memory to form the original Falmouth Nature Preserve. (Above, courtesy D. Ryan; below, courtesy M. Honan.)

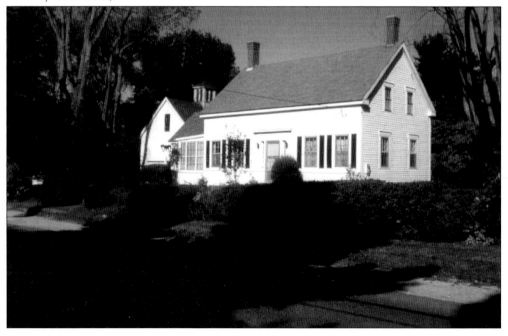

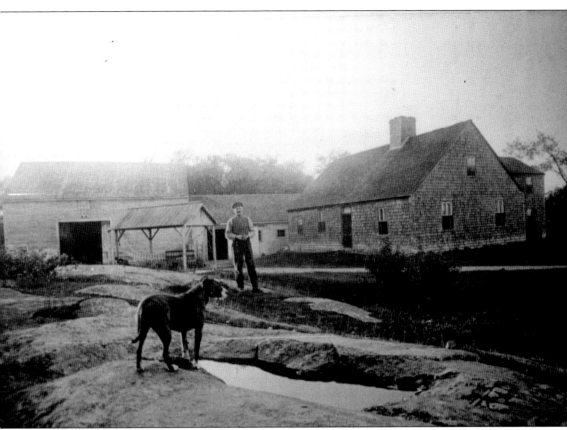

The Bucknam farmhouse is on the right side of Bucknam Road when driving from Falmouth Corners. The original house, built around 1750, was purchased from David McIntire by a Bucknam family member in the early 1800s. The Bucknams lived in the house until 1960 when it was sold to Clay Jordon, who modernized it throughout. The original house was a cape with one main chimney and four fireplaces. The beams were hand hewn and pegged with hemlock. There are indications that the original house might have been enlarged very early. A 1970 addition included a porch, mudroom, and dining room. When the railroad came to Falmouth in 1848, the tracks and depot were just below the location of the house. A road ran from Falmouth Corners to the depot and then east to Skillins Corner on Falmouth Foreside. When Interstate 295 was built, part of Depot road was closed, and Bucknam Road was created. (Courtesy FHS.)

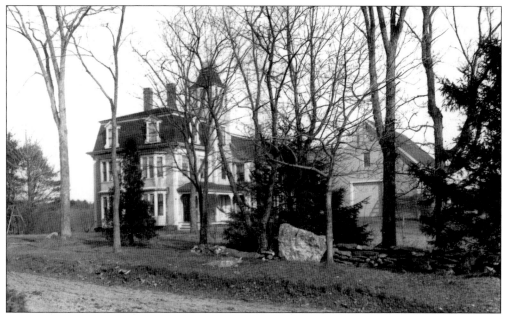

When Harlan Merrill built this house before his marriage in 1867, it was the first house on Merrill Road. The road was established only two years before. The land is part of a parcel along Falmouth Road purchased by his great-great-grandfather James Merrill in 1738. Harlan Merrill wanted something different when he built his house with the grouping of four front windows, a Mansard roof, and a tower. (Courtesy FHS.)

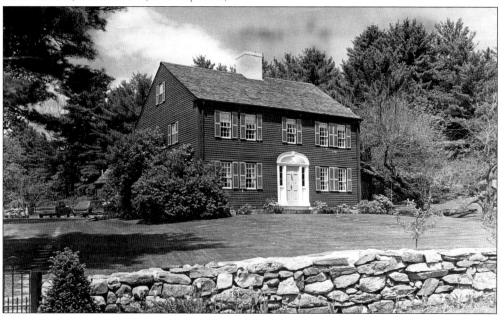

This magnificent home on Falmouth Road was built about 1878 on land above the Presumpscot River. It replaced a garrison house built by the original owner, James Merrill, who purchased the land from Brig. Gen. Samuel Waldo in 1738. James Merrill had 11 children, and it is said that he promised each one a house. There are many Merrill houses in Falmouth, so perhaps he did. (Courtesy FHS.)

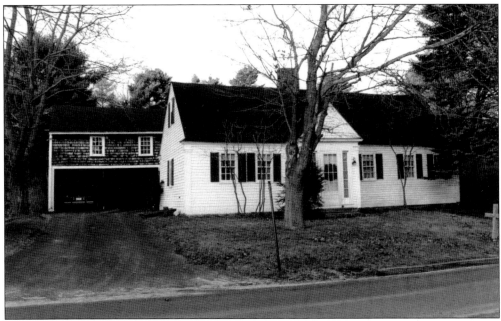

This house at 141 Falmouth Road at the intersection with Allen Avenue was probably one of the early Merrill houses provided by James Merrill to his children. Built in 1760, it remained in the Merrill family for generations. It was later called the Prince House, as several Merrill females married Prince males. The picture below shows "Mother" Prince and her faithful companion sitting in the home's kitchen. She had three daughters and one son. Her daughter Josephine (Josie) was a talented and noted photographer in her time. The entrance hall to this cape house was added later, but many features have changed little over the generations. (Courtesy FHS.)

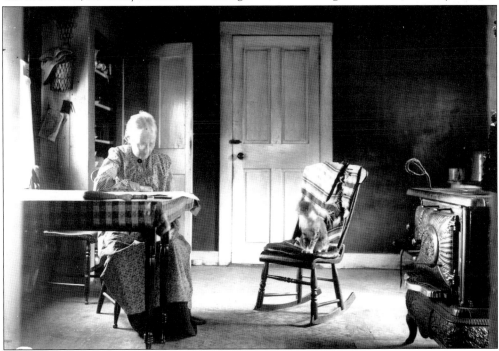

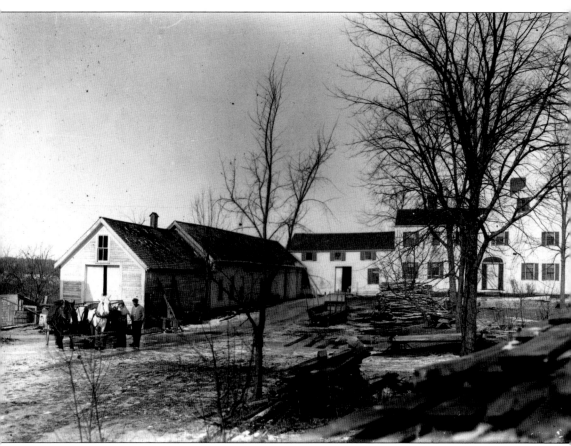

George Whitney lived in the home at 286 Falmouth Road for his entire 93 years. His father, from Cambridge, Massachusetts, had purchased 80 acres of land and the house in 1857. At one time, there were five farmhands living in a bunkhouse on the property. The Whitneys kept a dairy herd, which included cows that belonged to several prominent families in town. Young George Whitney remembered doing deliveries, making sure these families received milk from their own cows. The last section of the ell was an icehouse where he stored ice cut in the winter from the nearby Piscataqua River. As late as 1940, Whitney's wife made ice cream, which she sold in front of their house. The ice cream is still remembered as being superb. When Falmouth's new town hall was built, the old one was moved across the street by oxen where it stood on the Whitney farm for years. After Whitney's death in 1961, Mrs. Whitney moved to a smaller house on the farm. Soon after, fire destroyed the original ell, but firemen saved the house. (Courtesy FHS.)

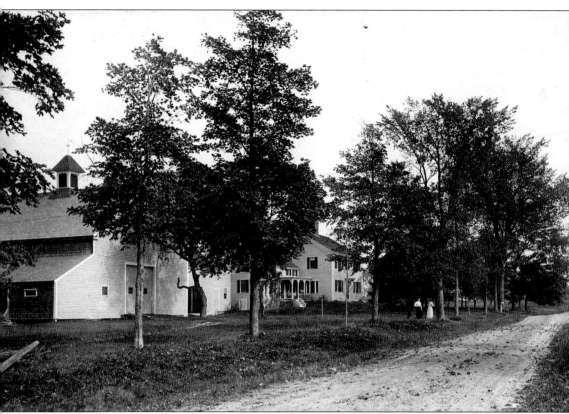

This beautiful 200-year-old farmhouse and its outbuildings are located at 100 Woodville Road at the intersection of Field Road. The house was built by Nathan Merrill in 1809. This 1900 photograph shows the narrow dirt road that is now paved. The house has never been sold. This set of buildings is a classic example of a Maine farmhouse with the gracious dignity of the Federal style and the convenience of an added kitchen and a bedroom. A spacious woodshed and carriage house provide ample space for winter wood and buggies. The carriage house was of earlier construction and was moved to connect the barn and house. One can open the door to the barn from inside, having come all the way from the house under cover. The present owner is a 10th-generation descendant of James Merrill. (Courtesy D. Merrill.)

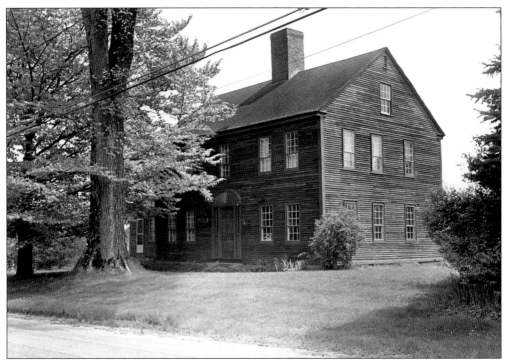

Henry Gallison, a blacksmith, was born in 1796. He came to Falmouth from Windham. Town records show that in 1825 he was paying taxes on a house, barn, and blacksmith shop located on Mountain Road at West Falmouth village. This handsome Federal-period home has been carefully restored, and it now stands much as it was when Gallison first occupied it. (Courtesy FHS.)

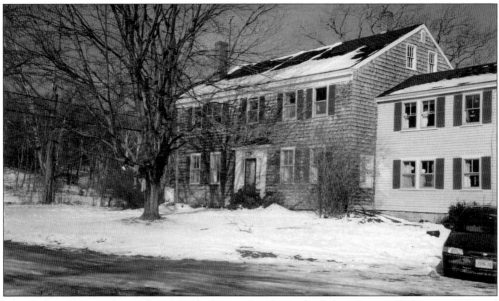

The Wilson Tavern, located at 613 Blackstrap Road, was built by Thomas Wilson in 1752 and was on the 1808 list of inn licenses. At that time, Blackstrap Road was the route to Gray and was used by the stagecoaches between Portland and Lewiston. The tavern was about nine miles from Portland and offered food, drink, and lodging to travelers. (Courtesy Norton family.)

The Marston homestead on Gray Road in West Falmouth was built in the late 1700s. The original cape-style house remains, with additions. The original well dug on this property exists today. In 1802, Benjamin Marston married Ann Hobbs. Mark Winslow, a direct Marston descendant, now owns the homestead. Below, Justin Winslow is working with his prize-winning oxen Duke and Dan. He is a direct seventh-generation descendant of Benjamin Marston and lives on the homestead with his family. This pair of yoked steers was purchased by Colonial Williamsburg in Virginia, as part of its presentation of 18th-century life. (Courtesy E. Winslow.)

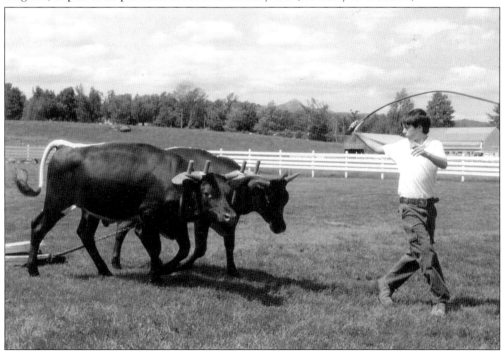

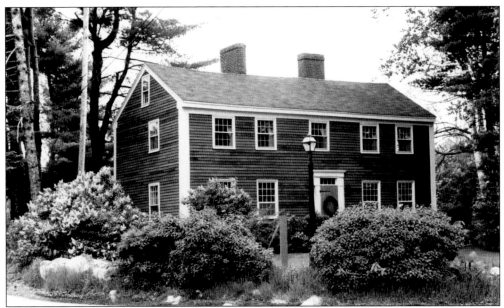

The Rockwall House is located at 492 Blackstrap Road. Quakers settled in the Duck Pond (Highland Lake) area of North Falmouth about 1750. The area had a blacksmith, a tannery, and a store all owned by the Morrell family. During the 1920s, many of the houses in the area were purchased by out-of-state people for summer homes. Barbara Switzer, a former teacher, had a tearoom here during the mid-1900s. (Courtesy FHS.)

The Elisha Purington House at 71 Mast Road is on the National Register of Historic Places. Elisha and Sarah Purington built the house in 1763 on 300 acres adjoining Duck Pond; the land was probably Sarah's dowry. Oxen towed mast trees to the shore on the road by this house. The Puringtons lived there for about 100 years. The Pride family owned it from 1870 through the 1930s. (Courtesy FHS.)

In the early 1800s, a Methodist society was formed at the Foreside by both Falmouth and Cumberland residents. In 1811, the church was incorporated, and a building was erected with half of it in each town. Members were encouraged to sit in their town, and the minister spent equal time in each town while conducting the service. In 1944, the congregation broke away from the Methodist Conference, became a community church, and now goes by the name of Foreside Community Church. The picture above shows the outside steps leading up to the entrance and burial sites on both sides of the church. The most recent picture shows a new entrance with the steps to the sanctuary inside and the parish house on the left. Burial grounds are still on the right. (Courtesy FHS.)

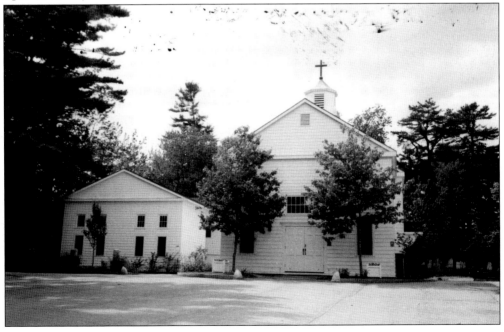

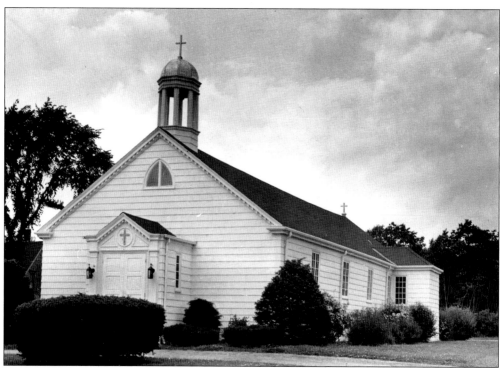

Holy Martyrs Catholic Church, dedicated to the Jesuit Martyrs of North America, began as a small mission under the Sacred Heart Church in Yarmouth. Land was purchased on Foreside Road in 1920. The first church, with white clapboard and a cross on top of a gold dome, was built in 1930. The membership grew so that additions were necessary. In 1967, Holy Martyrs was made a permanent parish. In 1970, the original church was razed, and the present church of red brick was constructed. In addition to the sanctuary, the building has a fellowship area, church school classes, and rooms for the parish priest. (Above, courtesy M. Honan; below, courtesy FHS.)

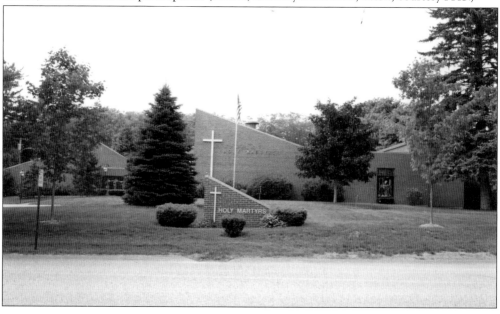

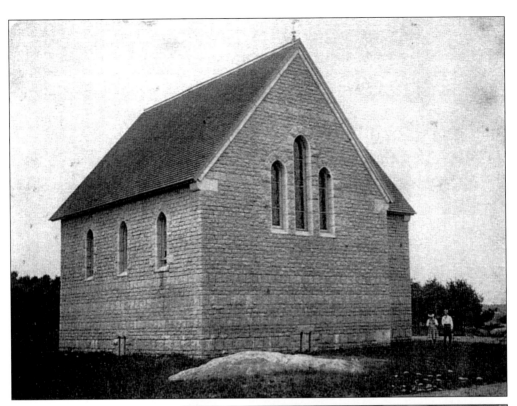

The cornerstone of the original Chapel of St. Mary the Virgin was laid in 1890 on three acres of the Thornhurst estate. It was the gift of Civil War general John Marshall Brown in memory of his daughter Alida G. Brown. She died at the age of 19 while studying in Switzerland. In 1902, with a bequest from his mother, the general added the impressive castellated Norman tower as a memorial to his parents. The church was designed to resemble the 12th-century church of St. Mary in Ifley, England. The impressive main entrance was added in 1949. It was built originally as a summer chapel, but since 1924, services have been held year-round. (Courtesy H. Russell.)

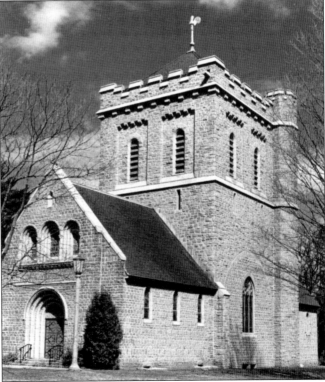

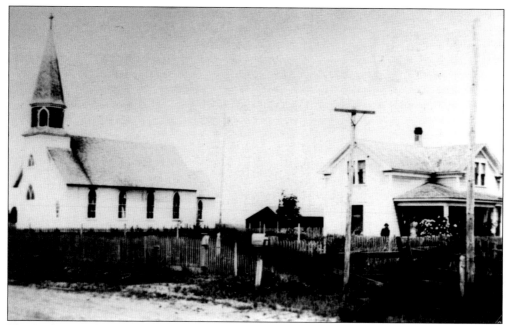

The Lutheran Church began when a group of women of Danish ancestry organized a Ladies Aid whose aim was "to further the Kingdom of God among us." In 1893, at Christmas the congregation held its first service in the new sanctuary. It boasted a wood burning furnace, chairs, hymn books and lamps and a $500 mortgage. In 1937, it was decided that English would be used in all services. (Courtesy FHS.)

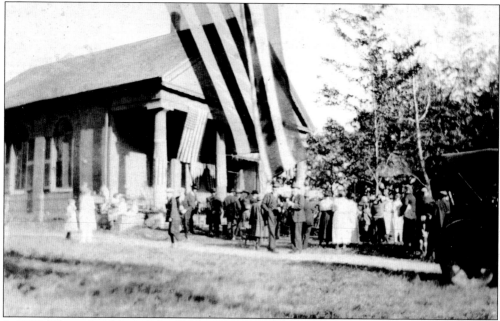

In 1920, Falmouth celebrated the 100th anniversary of the State of Maine. The location was the town hall and the Congregational church on Falmouth Road. There were speeches, competitions, a parade, races and a fireman's muster. Decorated, trucks, cars wagons and baby carriages were a feature. Food was important and the bean supper was a favorite. (Courtesy FHS.)

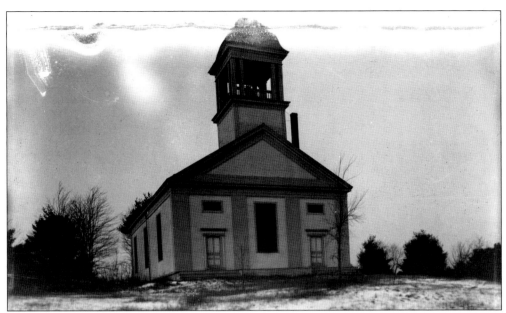

As early as 1735, 62 families in New Casco petitioned the first parish located in Portland for a second parish giving as a reason the distance they had to travel to worship, especially in bad weather. In 1754, a parish was approved, formed, and organized. The first meetinghouse was located near Scutterygusset Creek on Lunt Road. In 1804, a new building was erected on Falmouth Road near the present entrance to Ocean View at Blueberry Lane. Falling into disrepair, the church was rebuilt in 1841 as shown above. It was razed in the 1940s. A second parish was organized September 15, 1830, and the brick church was built next to the town hall using bricks made at the Merrill brickyard. Throughout the years, the two parishes shared ministers and in 1945, they joined congregations forming the Falmouth Congregational Church. (Courtesy FHS.)

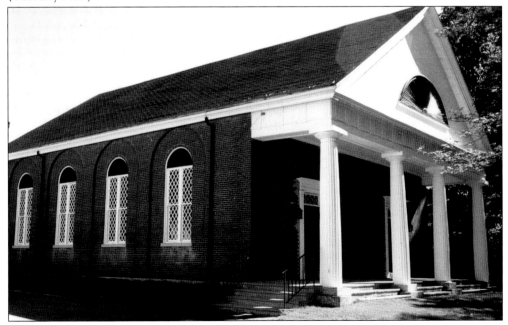

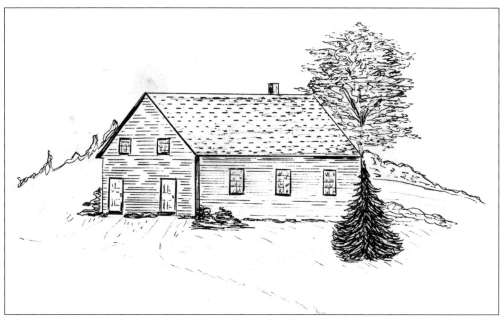

Around 1823, Jedidiah Leighton's wife, Mary Leighton, and a few other ladies began to hold prayer meetings that led to the formation of the West Falmouth Baptist Church. Mary Leighton and others were baptized, and a church was organized with about 39 members in 1829. The congregation met in the local school and in homes until 1839, when the first church was built on land donated by Jeremiah Hall. The original church building is shown as a sketch. The lower photograph shows the church and attached church education building as it appeared in 2008. (Courtesy FHS.)

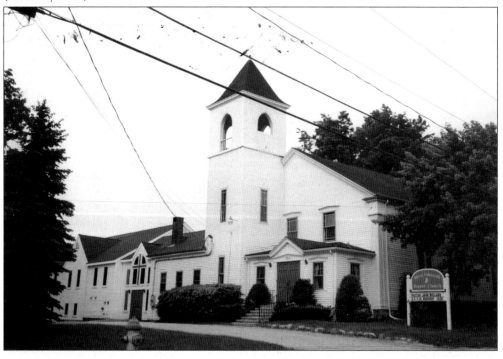

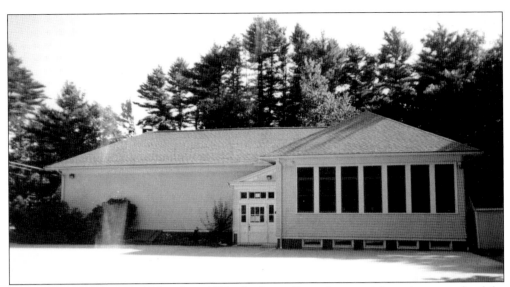

When Pine Grove School closed in 1978, the lower Foreside was without its own school for the first time since 1809. In 1916, a fire damaged the 1860s structure just a few days before the September opening of school. Students then attended Underwood School on the upper Foreside for the next year during the rebuilding. After Pine Grove School was closed in 1978, it was sold, renovated, and now houses a private school. Pictured below are students at Pine Grove School during the 1928–1929 school year. From left to right are (first row) Richard Knudsen, Betty Jean Witherley, Betty Brackett, Arlene Griggs, Carla Anderson, Donald Branscomb, and Ronald Ferguson; (second row) Clarence Howard, Kenneth Howard, Alan Lawson, Leona Borge, Marjorie Knudsen, Geraldine Lawson, Waldo Strahn, Roger Blanchard, and John Owen with teacher Phyllis Forestall. (Above, courtesy FHS; below, courtesy B. Knudsen.)

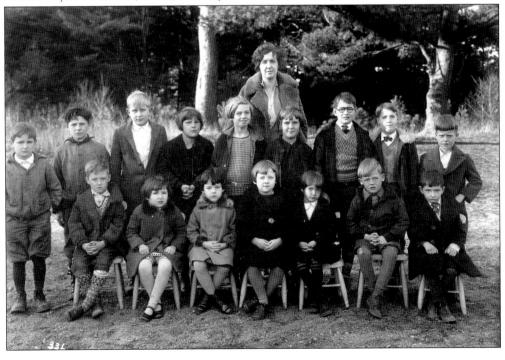

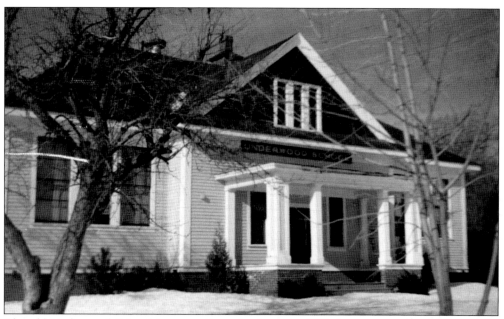

The old Underwood School in upper Foreside closed in 1916. It was moved and became the Foreside Garage. The Pine Grove School fire in 1916 brought all those students to the new Underwood School. It was closed in 1975 and was burned down as a fire exercise in 1981. Pictured below are Underwood School students in 1942. From left to right are (first row) Russell Edwards, Rebecca Penny, Anne Austin, Josephine Morris, Ruth Penny, Gail Randall, Sally Davis, Virginia Newton, and Gwendolin Miller; (second row) Bruce McGorrill, Teddy Taplin, Winthrop Smith, Gerald Miller, Thomas Rice, Donald Omerod, Eleanor Libby, Anita King, Joseph Morris, Arthur Boulay, and Donald Meany; (third row) Esther King, Richard Spear, Bruce Clement, Kenneth Jordan, Edward Morris, William Stubbs, Michael Payson, Ormand Brown, Robert Rice, and Daniel Davis; (fourth row) Caroline Chesley, Wallace Soule, Robert Irish, George Hyde, John Pettengill, Richard Hill, Dorothy Estabrook, and Horace Hildreth. (Above, courtesy FHS; below, courtesy J. Hyde.)

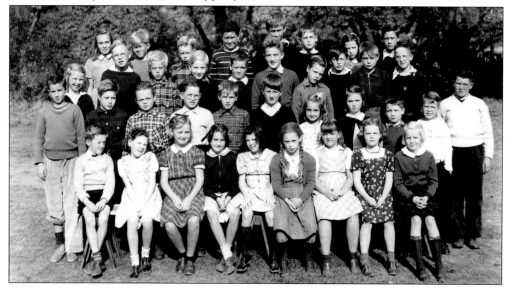

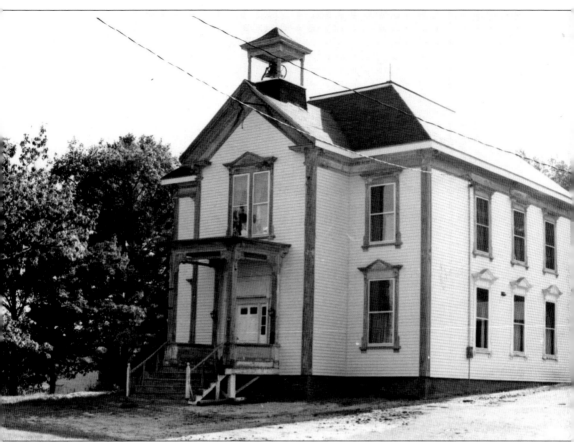

The first school in the Pleasant Hill area was a redbrick building called the Presumpscot School. It was torn down and replaced by a new wooden school, built about 1880 from a legacy of Crispus Graves. Legend has it that Graves would drive by in his carriage and stop to talk to the children. Because he was so impressed by their politeness, he willed money to the district to be used for their benefit. The new school was called the Graves School. At one time, the building housed four primary rooms on the first floor and four grammar school rooms on the second floor. Trustees were elected to take care of the fund. The trustees sold the school to the town in 1897 for $1,200. A bell was installed by the town after the students solicited funds around the area. The bell was ordered by teacher Anna Colley between 1910 and 1912. In 1947, the school was discontinued, and another one was built across the street. That school was closed in 1975. A small park is on the site today. (Courtesy FHS.)

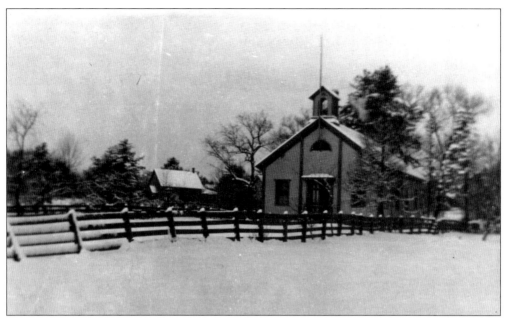

The old D. W. Lunt School, named after the former superintendent of schools, was built in 1867 at Falmouth Corners. The two-room school had a large playground facing Middle Road. The old building is now a garage. The new Lunt School was built behind the high school on Lunt Road. Many former students remember the transition to the new building. Millicent Teague and Mildred Cole were teachers at both the old and new schools. District four school (below) on Falmouth Road was called the Barker or Brick School. Leonard Merrill, who lived nearby, gave his daughter land when she married a Barker. In 1830, she gave the town a small parcel of land on which to build a school. Bricks from the Merrill brickyards were used. The school closed permanently in 1916. It is now a private home. (Courtesy FHS.)

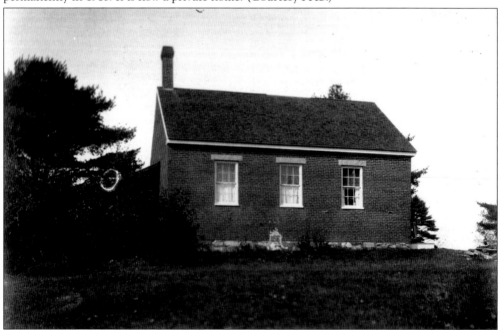

In the very early 1950s, the Lions Club sponsored the first Little League team in Falmouth. Here they are ready to be scouted by the big leagues. Seen here are ? Chipman, Frankie Parker, Robert Curran, Cappy Worth, Freddy Harlow, Earl Doughty, Phillip Soul, Brian Rich, Larry Shaw, Louis Brown, Coach Sonny Cole, Paul Potenzo, Douglas Campbell, Clark Taylor, Paul Soule, and John Libby. (Courtesy L. Shaw.)

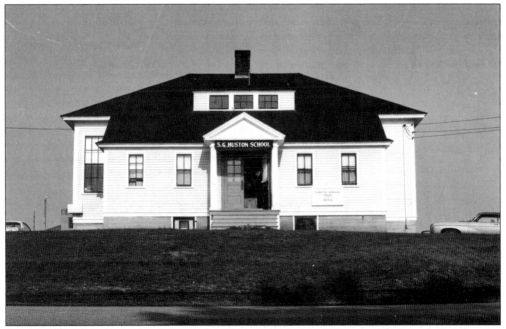

District No. 7 has had schools located at the intersection of Winn and Falmouth Roads since the 1780s. The Huston School, named after a former selectman, was built first as a two-room building, but grew as more families came to this area. The school was closed in the summer of 1980. It was demolished and the site used for a new fire station. (Courtesy FHS.)

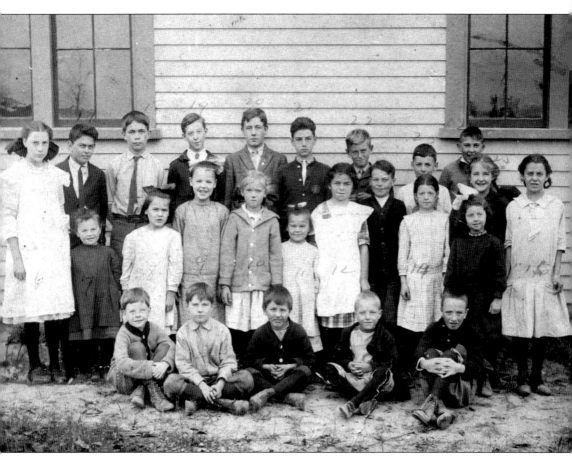

This is probably the last day of school in 1912 for these students at the Piscataqua School in West Falmouth. Everyone is dressed in his or her best for this picture. The girls have on white dresses, and the older boys have coats and ties. The younger boys in front have been told to mind their manners. The teacher has not been identified; perhaps he is the young man in the middle of the third row. The students are outside their one-room school building. Identified here are Charlie Littlejohn, Paul Hampson, Ellery Huston, Keith Mountfort, Peris Knight, Angie Huston, Olive Huston, Effie Hatcher, Margaret Peterson, Elva Huston, Clara Hawkes, Steve Huston, ? Field, ? Field, Clara Morrill, L. O'Brien, Dana Charles, ? Littlejohn, ? Charles, Benjamin Lunt, Maurice Winslow, Sammie Lunt, Roy Huston, and ? Littlejohn. (Courtesy FHS.)

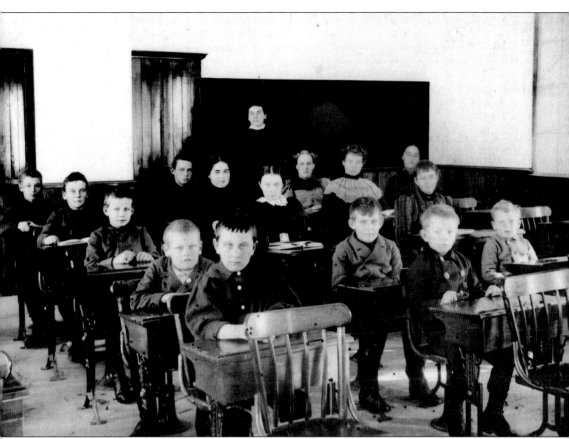

The new Hurricane School replaced the old red schoolhouse near the new Gray Road. Built by Robert Lowe in 1897, it cost $1,059. It had two doors in the front with cornices over the windows and doors. The old school had a fireplace; the new one had a stove. A tower with a bell was added later. Families in this area had many children. James Hicks had 15 children, and Isaac Huston had 18, so it is not surprising that there were as many as 50 children in one room. After the school closed in 1928, it was moved and converted to a private home. The following students are pictured in 1897: Philip Sommers, Percy West, Nellie Leighton, Walter Leighton, Grace Hadlock, Barbara Hodgdon, Tom Sommers, Ella Hicks, Dot Hadlock, Ralph Winslow, Ellis Leighton, Jennie Sommers, Clarence Harmon, Charlie Sommers, Clarence Leighton, and teacher Lizzie Colley. (Courtesy E. Winslow.)

There were two Blackstrap Schools. One was located between Mountain and Mast Roads and the other on Babbage Road. This sketch by Falmouth artist Hannah Russell represents a brick structure. This was torn down, rebuilt, and used as fire station in West Falmouth. The other Blackstrap School was in operation until 1946 (Elizabeth McCann taught there). Howard Babbage, a 1928 pupil, remembers the brown shingles, furnace in the basement, and two chemical toilets. The photograph below was taken in 1916 outside the Dunham School located at the corner of Field and Winn Roads. It is now a day care center. Teacher Inez O'Brien is in the second row on the left. The students are Doris Parker, Chester Libby, John Bell, Carl Terison, Alberta McCann, Lyden Terison, Bernie Breck, Mattice Libby, Howard Peterson, W. Parker, and Richard Bell. (Courtesy H. Russell.)

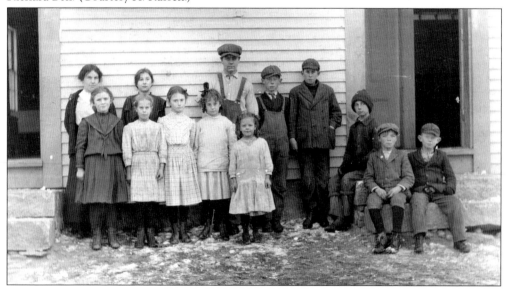

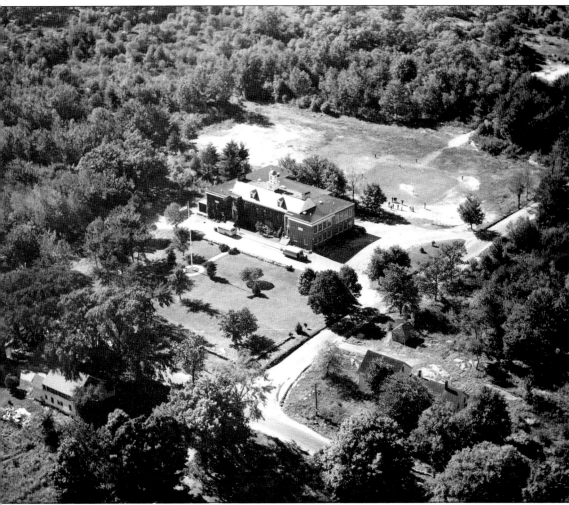

Falmouth High School was built in 1931 at Middle and Lunt Roads. It was called one of the finest buildings of its type in Maine. It served an average of 250 high school and junior high school students each semester. High school–age students had attended schools outside of town for many years. The aerial view shows the Lunt School in the upper right corner. In 1935, the first school bus was brought into the system. It was during the old home day parade in 1935 that citizens could see the newest trend in educational services. A new Falmouth High School was built on 75 acres of land on Woodville Road in 1956. In 1965, it was enlarged to accommodate the Falmouth Middle School. The Lunt Road facility continued as the junior high school until 1965 when it was converted to a grade school. In 2009, plans are underway to build a new elementary school and consolidate all classes on the Woodville Road campus. (Courtesy FHS.)

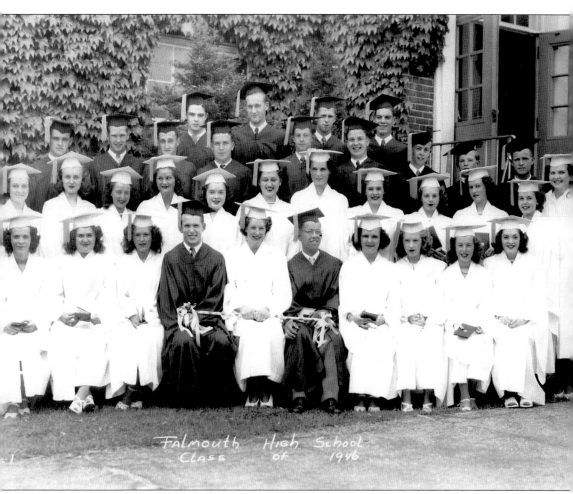

The class of 1946 graduated at an interesting and challenging time. World War II had ended a few months before. Troops were returning home and being discharged. The job market was beginning to change back to civilian interests, and there was much competition. Pictured from left to right are (first row) Carleen Casparius, Mary Dyer, Christine Eames, David Merrill, Muriel Ricker, Donald Rose, Marilyn McKenny, Phyllis Dahlberg, Phyllis Wheeler, and Janice Grover; (second row) Priscilla Hanson, Evelyn Hughes, Roberta Estabrook, Joanne Chapple, Barbara Dresselly, Iola Merrithew, Irene Hansen, Constance Tormay, Alice Pfeffer, Marion Reynolds, Lois Mayberry, and Betty Marston; (third row) Darrell Mileski, Fred Howland, Frank Wilson, Rodney Cole, Moulton Doughty, Raymond Cole, William Chesley, David Fabricius, and Walter Phillips; (fourth row) Leroy Morse, Bradford Meehan, Ralph Winslow, and Edward Perry. (Courtesy FHS.)

Four

People, Organizations, and Events

A town is not defined by its buildings, stores, houses, churches, schools, and roads. These things make up the stage upon which residents play out their lives interacting with others. People work together as volunteers or as employees on a job. They are families, churchgoers, and members of organizations. They are all actors in the great play called life, and they contribute to the grand drama as they can with whatever talents they may have.

As information for this book was gathered, it was interesting that so little information exists about some individuals and so much about others. There are the "doers," whose records are filled with a long list of educational achievements, employment accomplishments, organizations they have joined, and places they visited. It seems like they were applying for a job and want to be sure that all details were spelled out.

Some folks have focused on their genealogical lives and have an obituary that lists all relatives, including second cousins back to the original settlers. Contrast this with the individual who remained in his birthplace, got married, raised a family, and was employed locally for many years. He was a member of his church, belonged to a fraternal lodge, helped with the Boy Scouts, and loved hunting and fishing. This person did what needed to be done without much fuss and bother and was content to enjoy the simple pleasures of life.

The Falmouth Historical Society's files contain photographs with little or no information about the names, places, or dates. Even recent photographs have little information. There are many interesting stories about Falmouth people that are not recorded, but the society would like to add this information to its files.

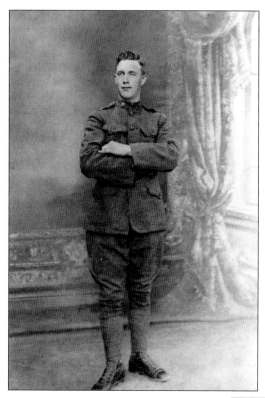

Freeman G. Cleaves Jr. stands proudly in his uniform while on duty in France in 1918. Pictures like this were a joy to parents and friends back in Falmouth. He was a handsome young man. The picture below was published in the *Portland Press Herald* and taken at a Memorial Day parade. He was the only World War I veteran to march. He was the son of Freeman G. Cleaves Sr., who was the first of four generations to live on a 40-acre farm off Pleasant Hill Road. The family worked the land and produced an abundance of fruits and vegetables. Freeman Jr. was a longtime member of engine No. 3 of the Falmouth Fire Department and served the town in many other volunteer activities. (Courtesy Cleaves family.)

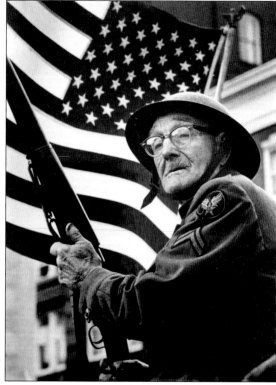

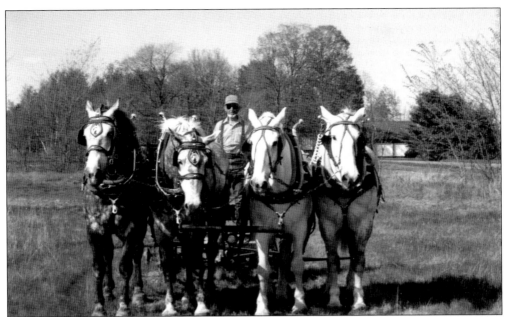

Loring "Uncle" Norton of Gray Road raised horses at Blackstrap. He drove sulky horses at all the fairgrounds and at Scarborough Downs. During the holiday season, he gave rides on his hay wagon. His horses and vehicles were hired for weddings, special events, and parades. He operated Hurricane Ski Slope and served hot chocolate in the barn to cold skiers. (Courtesy Norton family.)

Robert Hartford Cram was raised in Cumberland but lived in Falmouth. He graduated from a New York college with a degree in landscape architecture. He was a professional gardener who worked with clients along the Foreside. He retired at age 82 to his home on Hartford Avenue where he maintained an extensive flower and vegetable garden and was always available to help friends and neighbors with gardening problems. (Courtesy M. Wilson.)

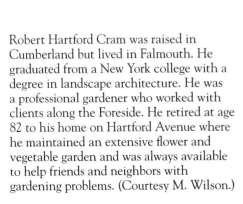

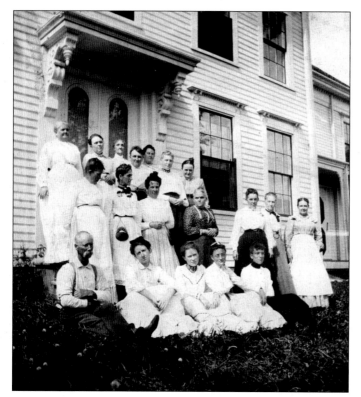

This house on Gray Road at Mill Road hosted a *c.* 1890 gathering. Seen here are Charlie Huston, Nellie Bach, Hat Huston, Ellis Horlis, Liz Mountfort, Mrs. Marston, Jake Mountfort, Della Marie Ford, Julia Marston, Mrs. Freege, Mary Leroy, Ella Huston, Ruth Field, Aunt Net, Aunt Maruthy, Annie Flynn, Aunt Grace, Bertha Blake, and Liza Lunt. (Courtesy FHS.)

Oscar Fredriksen was a sailor on large ships from Norway that came to Canada and Portland. Settling in Falmouth, he was a master gardener for many of the old estates. He taught his grandchildren how to ski and toboggan on the seven hills near Mill Creek. The field seen at mid-right is now the Skillins tree and shrub department. (Courtesy D. Fredriksen.)

After Mary Morris and James E. Honan were married at Holy Martyrs Church in Falmouth Foreside on August 8, 1953, her father, John Morris, met them at the door of the church with an Irish jaunting cart, which came from Ireland for the occasion of his oldest daughter's wedding. Here is the cart leaving the church as John drives the happy couple proudly down State Road to the Morris home for the reception. Barbara Ellen Morris, Mary's sister and maid of honor, is to the right of her proud father. She waved to her friends all along the route. Not pictured is John J. Honan, brother of the bridegroom and best man. A local news photographer took this picture; it went out on the news wire and was published all across the country. (Courtesy Honan family.)

Laura Amelia Jensen and Iver Hansen Iverson II were married on September 12, 1905. In 1908, Iver purchased land at the intersection of Lunt and Depot Roads and built the Victorian-style cottage that became the Falmouth Memorial Library in June 1951. The library has a collection of 46,000 books and 1,200 videos. The Russell Room, established in memory of John Russell, provides seating space for up to 90 people for meetings. Children's story hours, outreach programs, and good reference resources make this an excellent community library. Hundreds of books are made available each year to the community at family and children book sales conducted by the Friends of the Falmouth Memorial Library. The Falmouth Foreside Garden Club maintains the attractive plantings in the perennial garden and the shade garden. (Courtesy FML.)

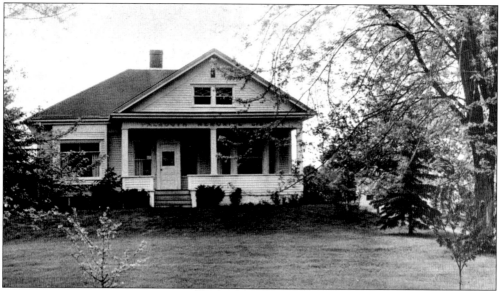

James Iverson (below) was the first Falmouth resident killed in World War II. A staff sergeant in the U.S. Army Air Corps, he served in the South Pacific. He received the Purple Heart and the Distinguished Flying Cross. The Falmouth Memorial Library is named for him. His second cousin Andrew Iverson (right) served as a chief petty officer in the navy in the Aleutian Islands. Upon his return, he founded the Andrew P. Iverson Plumbing Company in 1948. Andrew helped to organize the Falmouth Lions Club and was a commander of the American Legion Post No. 164. Iver, Martin, and Andrew Iverson were three Danish brothers who fled Schleswig, Germany, in the mid-1860s to avoid fighting in the German army. James was the grandson of Martin Iverson. Andrew was the grandson of Andrew Iverson. (Right, courtesy C. Kauffman; below, courtesy American Legion.)

John J. Morris Sr., was the first chief of police in Falmouth. Appointed by town selectmen on April 1, 1939, he was also a deputy sheriff for Cumberland County. He was a one-man police force, officiating at many activities in the town. Morris came to America from Galway, Ireland, as a young man during World War I. He became an American citizen and joined the U.S. Army, serving in the occupation of Germany. He moved to Falmouth in 1925 and family still resides in the same home. During World War II, young men joining the armed forces needed a letter from the chief of police stating that they did not have a police record. He was active in the town's civil defense program. He is shown here with Charles Morrill at the Portland Country Club. (Courtesy M. Honan.)

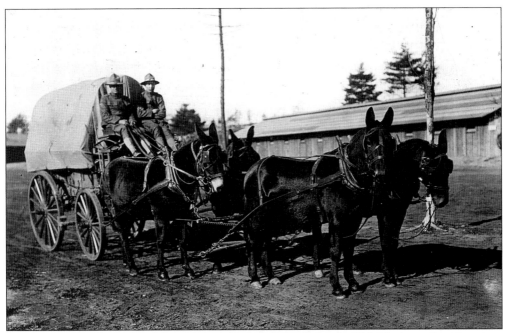

Henry H. Mitchell of Falmouth is driving a four-mule hitch for the 35th Machine Gun Battalion in World War I. He was the father of Robert Mitchell of Falmouth. This picture brings nostalgic memories of how different each war was and how young men adapted to what ever was needed, even driving a four-mule team. (Courtesy Mitchell family.)

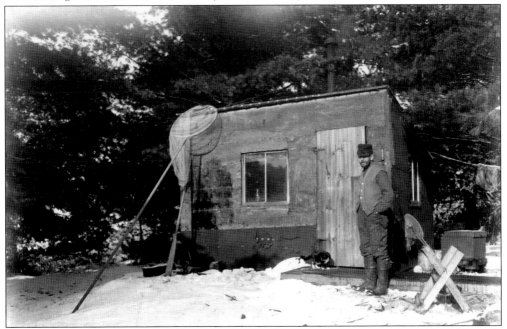

Harry Whitehouse was very well known in West Falmouth. He lived very frugally in his little house on the bank of the Presumpscot River. A very quiet man, he kept to himself and worked occasionally to get just enough money to take care of his needs and food for his dog. He was very resourceful in setting traps for small animals and liked to go fishing. (Courtesy FHS.)

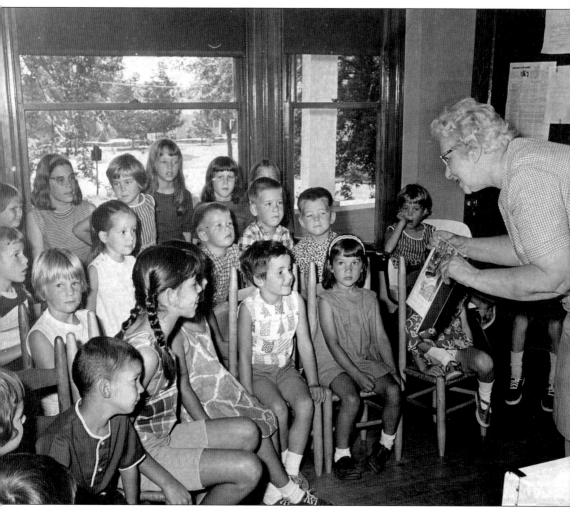

Sadie O'Brien, the storyteller in this picture, is entertaining children at the Falmouth Memorial Library. Children were her delight in life, and she spent much time giving information to them. She loved to tell Bible stories from her big book. Children in her Sunday school class knew about the people in the New and Old Testaments. At the library, she talked about Falmouth. Her stories included real people, facts, and stories of their lives. She identified houses in Falmouth and told the children about the people who lived there. Early Falmouth was always interesting to O'Brien, and she shared that interest with young and old. The files at the Falmouth Historical Society have many pages written in her easily identifiable handwriting. She continued to write down memories about people, places, and events when she could no longer walk, and she entertained visitors with stories of Falmouth. O'Brien was a member of the Falmouth Historical Society and contributed greatly to its reference materials. (Courtesy FHS.)

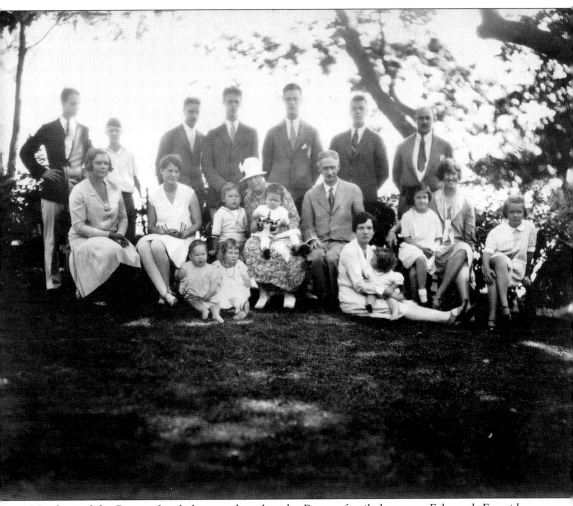

Members of the Payson family have gathered at the Payson family home on Falmouth Foreside in the early 1930s. Their children, spouses, and grandchildren surround Herbert Payson and Sally Brown Payson, seated in the center of this photograph. Herbert Payson was active in the management of the H. M. Payson Company in Portland. A private investment company, it once had extensive holdings in water companies in seven states. The company is noted for its conservative investment policies. Charles Shipman Payson and his wife, Joan Whitney Payson, were active in the preservation of art. They donated Winslow Homer paintings to the Portland Museum of Art. She was the very active owner of the New York Mets. Identified here are Joan Whitney Payson, Nancy P. Holt, Sally Brown Payson, Herbert Payson, Eileen Payson (the wife of Herbert Payson Jr.), Alida P. Snow, Herbert Payson Jr., Roger Snow Jr., Benjamin Holt, Olcott Payson, Charles Shipman Payson, John Payson, and Roger Snow. (Courtesy L. Snow.)

Three boys grew up to be special citizens of Falmouth. Above, from left to right, Ted Vail became a longtime well-liked educator, Ted Russell became a medical doctor, and John Jewett Russell became a business executive. John (1928–1991), seen at left, graduated from high school in the middle of World War II and joined the navy. Later he worked for Consumers Water Company in Maine, Massachusetts, and Illinois. He retired after 25 years and in 1968 joined Hannaford Brothers. He retired as senior vice president of finance but remained on the Hannaford board. As young man, he was a Boy Scout and he continued this work as an adult. He served the United Way, the Falmouth Town Council, and was life member and longtime treasurer of the church of St. Mary the Virgin. He married Hannah Talbot, and together they raised three sons. (Courtesy Russell family.)

Roger Vincent Snow was born in Portland on June 10, 1918, the eldest son of Roger Vincent and Alida Payson Snow. After graduating from Williams College in 1940, he pursued a career in journalism that took him to the *Portland Press Herald* and *Evening Express*. In 1956, he married Nancy Lee Snow, and they raised their family of four children in Falmouth. Eventually, he became owner of the Westbrook American Journal and later president of the Abenaki Company. He served two terms in the Maine State Senate and one in the Maine House of Representatives. He played important roles in establishing the Maine State Museum and in creating the Consolidated University of Maine System. He was active in local politics, serving as a councilman. An avid biker, he advocated bike paths in the town. In 1997, he was awarded Falmouth's Citizen of the Year Award. He died in 2006. (Courtesy Snow family.)

The four sons of the Vail family graduated from Falmouth High School and served in World War II. They attended the dedication of the World War II Memorial in Washington, D.C. H. Theodore (Ted) Vail graduated in 1945 and served in the occupation of Germany until 1947. Jackson B. Vail graduated in 1935 and served in the army from 1941 until 1945 as a staff sergeant. He was wounded seriously, hospitalized briefly, and returned to action. He was awarded the Silver Star for gallantry in action and the Purple Heart for his wounds during the Battle of the Bulge. Thomas E. Vail graduated in 1938 and served in the U.S. Army Air Corps from 1941 to 1945. As a lieutenant, he was a B-17 bombardier, flying 55 missions from North Africa over Italy. Robert B. Vail served in the U.S. Army Air Corps from 1942 to 1945. As a staff sergeant, he was a B-17 gunner/radio operator for 18 missions over Germany. His plane was shot down and half the crew survived. (Courtesy T. Vail.)

After World War I, veterans formed the American Legion. The Falmouth post was chartered in 1946 and purchased land from Herbert Brown. This included the building site and playing fields now owned by the town. The post building was constructed in the 1950s. Over the years, the legion has had a declining membership and most of those still active are World War II or Vietnam War veterans. The American Legion Auxiliary was formed in 1947. It has assisted the local chapter, has promoted national veterans' programs, has assisted local veterans and their families, and has supported many other community service programs. In this late-1950s picture are, from left to right, newly elected officers Katherine Heikkinen, Mary Morris, and Audrey Curry (standing). (Above, courtesy American Legion files; right, courtesy Honan family.)

At left, these Falmouth veterans are home from World War I and are proud to march in the annual Memorial Day parade. The only person identified is Carl Russell in his U.S. Navy uniform at the right of the flag. Every year, the Falmouth Historical Society banner is carried in the Memorial Day parade. The sprightly banner carriers prance along with all of the young ones. Other society volunteers ride in antique cars and wave to their friends watching the parade. Below, Nancy Merrill (left) and Mary Honan, with the banner, are followed by Girl Scouts. The parade ends at Pine Grove Memorial Park with an appropriate ceremony led by American Legion post members and aided by the combined bands and choruses of the middle school and the high school. (Left, courtesy Russell family; below, courtesy FHS.)

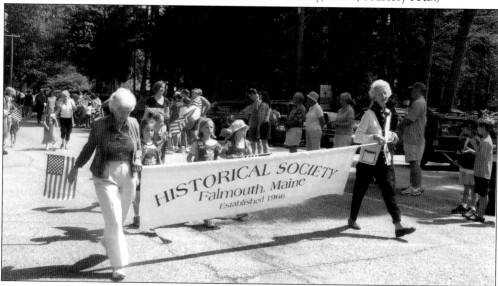

Falmouth has a very active Scandinavian population, especially the Danes. In the late 1930s, Girl Scout Troop No. 13 learned Danish dances, practiced for weeks, donned traditional Danish costumes, and then gave a performance at Portland City Hall. The dancers were Marilyn Sturdevant, Muriel Groves, Margaret Groves, Shirley Lumsden, Arlene Golding, Dorothy Dunsmore, Gwendolyn Dunsmore, Elizabeth Perry, Dorothy Quinn, Betty Stuart, Jane Sickles, Marry Morris, Patty Webster, and Janet Smith. The girls were taught these traditional dances by Rita Luja. The early Scandinavian settlers of Falmouth's were joined over the years by friends and relatives. They have been a rewarding addition to the community. Their knowledge of survival in cold bleak winters helped those who came from towns with the milder English climate. They are very proud of their customs and methods, their unique traditional clothing, and annual celebrations. (Courtesy FHS.)

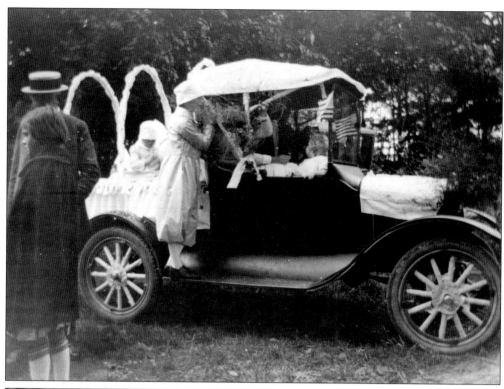

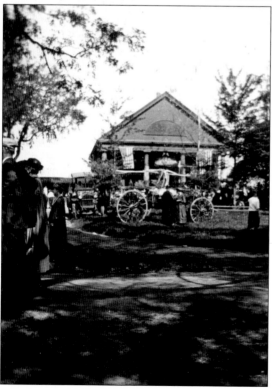

The old home days were fun. There was a firemen's muster, road races, and other skill-needing events. Prizes were given for the best-decorated doll carriage, bicycle, car, wagon, or anything that could join the parade. After the parade, there were good things to eat, and some of them were prizewinners, too. This is the day when town ladies and some of the men cooked a bean supper for everyone. This event was held at the town building and the Congregational church. (Courtesy FHS.)

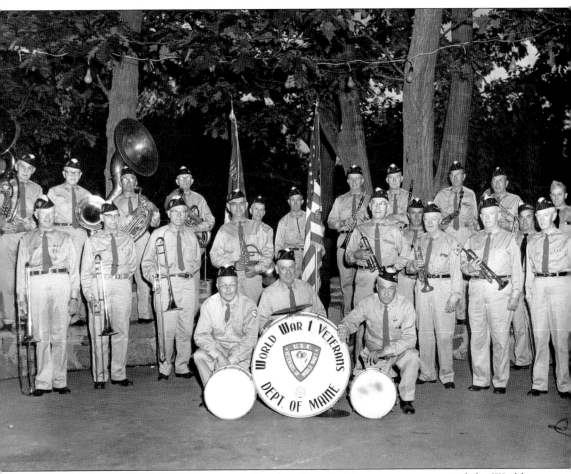

In 1961, 23 former World War I veterans who played musical instruments organized the World War I Veterans Band of Maine. They met and rehearsed in the Falmouth Fire Barn. Members had served in the Maine National Guard; the 54th, 72nd, and 73rd Regiments; and the 19th Coast Artillery during 1917 and 1918. This group had the distinction of being the only one of its type in the country. The band gave public concerts in Maine and performed at several national meetings of veterans. Members of the band, the band auxiliary, and friends formed the Hootenanny Group to play for dances and social events. Freeman G. Cleaves Jr. of Falmouth, also a veteran, did not play a musical instrument, yet he was an important participant in the formation and operation of the band. It was his job to set up the electrical equipment, provide transportation for the large musical instruments, and measure members for their uniforms. (Courtesy Cleaves family.)

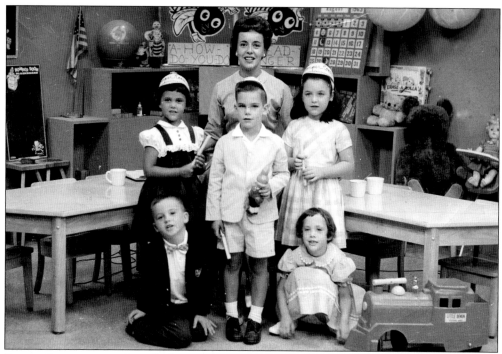

Romper Room was a syndicated television program in the 1950s and 1960s at many locations across the country. Jimmy Honan is standing and Marie Youngs is on the floor. Connie Rousseau was the local hostess. Children who wanted to be on the program were readily accepted. (Courtesy FHS.)

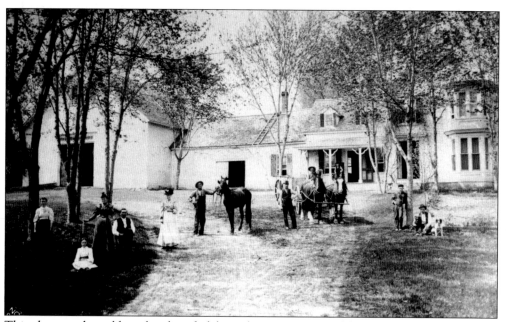

This photograph could not be identified, but it has great potential for a story. The owner of this house is posing for a picture with his possessions. His wife and daughter are by his side. A relative stands to the left and a cook or housekeeper stands to the right. In the background are several hired hands with a prized horse, a wagon and team, and two dogs. (Courtesy FHS.)

Five

TRANSPORTATION

Before 1718, Falmouth residents traveled by boat, old Native American trails, or primitive dirt roads. Ferries and later covered bridges helped with crossing the Presumpscot River. The King's Highway was the main road north from Boston. Stagecoach routes were developed and by the early 1800s, and there were lines to northern and western Maine. Local inns along the stage routes were a necessity since the coaches traveled about 9 to 18 miles per day, depending upon the weather. Bucknam, Lambert, Wilson, and Falmouth taverns served the stages.

In 1842, the Portland, Saco and Portsmouth Railroad and its connections provided service from Boston to Portland. In the spring of 1848, the Atlantic and St. Lawrence Railroad extended rails over the Presumpscot River at Staples Point through the town of Falmouth to Yarmouth and beyond. Service began at the station on Depot Road. The railroad later became the Grand Trunk Railway line between Boston and Montreal. The building of the railroad bridge at Staples Point created a problem for the shipbuilders on the Presumpscot River. Ships could not pass under the railroad bridge. Ship building activities moved to the estuary or to the Foreside shore. Tracks were laid through West Falmouth by the Portland and Kennebec Railroad to serve Lewiston and northwestern Maine. In 1870, it became part of the Maine Central Railroad system.

By 1900, the electric trolley had revolutionized commuter travel. Falmouth was served by two lines. The Portland and Yarmouth Electric Railway followed Route 88 to Yarmouth and Brunswick. Service began on August 18, 1898. The company opened Underwood Park on July 18, 1899. A steam-powered electric generating plant was built in Falmouth on Powerhouse Road. The Portland Yacht Club is now located on that site. A second line came out from Washington Avenue in Portland to West Falmouth and then to Gray and Auburn. By 1940, most of the interurban trolleys were replaced by busses. On May 4, 1941, service on all the Portland trolley lines was stopped. Falmouth received service on the bus route to Yarmouth until 1978.

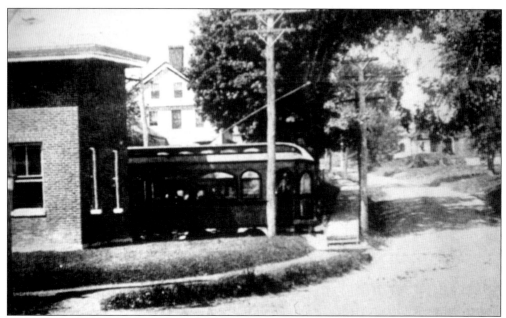

The trolley was a boon to residents of West Falmouth. This brick building at the corner of Mountain and Gray Roads was the power station and is still in use as a home. Note the boardwalk running along Mountain Road up to the West Falmouth Baptist Church. The Gallison house is on the left. (Courtesy FHS.)

By 1850, railroad service to Boston was available from the Falmouth station. Later it was possible to travel all the way to Montreal in one day. On October 2, 1966, this Canadian National Railroad steam engine crossed the Presumpscot River on the Staples Point Bridge on its last run. Diesel engines had replaced steam. (Courtesy Portland Sunday Telegram.)

Here are Richard and Marjorie Knudsen standing besides the family Marmon automobile. They attended the Pine Grove School near their home. Early Marmon automobiles raced at Indianapolis Speedway. The Marmon Company was very innovative introducing the first side view mirrors and experimental 16 cylinder engines. This was a very well designed automobile. Below are Gardner and Oliva Merrill who grew old together with their 1931 Franklin coupe automobile and its air-cooled engine. The car is doing well and in memory of his parents, the current owners drive the car to New York state to meet other aging Franklins at the annual Franklin gathering. (Above, courtesy B. Knudsen; below, courtesy D. Merrill.)

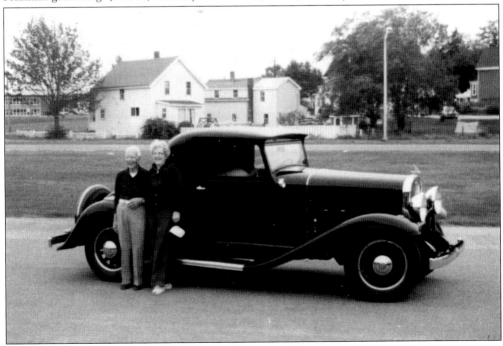

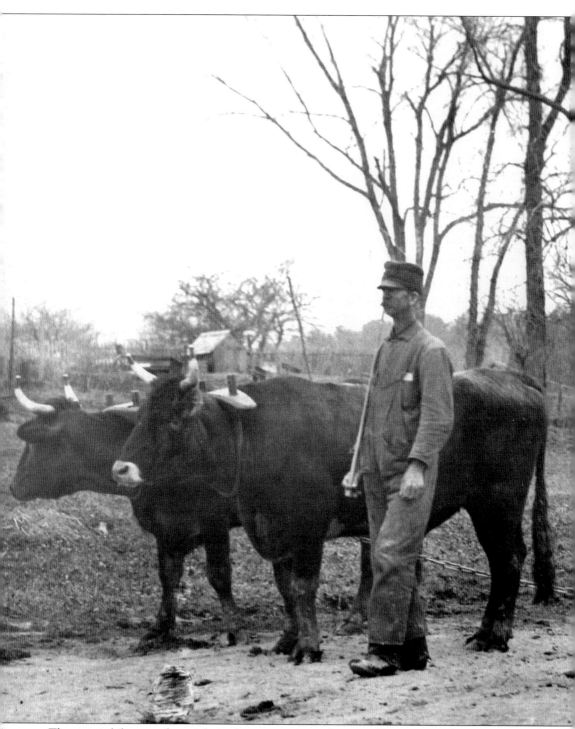

The automobile created new jobs in the transportation business. For instance, the manufacturing of buggy whips declined, but automobile engine repairmen were in demand. Blacksmiths found a new source of income in repairing broken axles and springs. Paved roads were rare. Oxen and horses could go through a muddy patch with little effort, but speedy four-wheeled motorcars

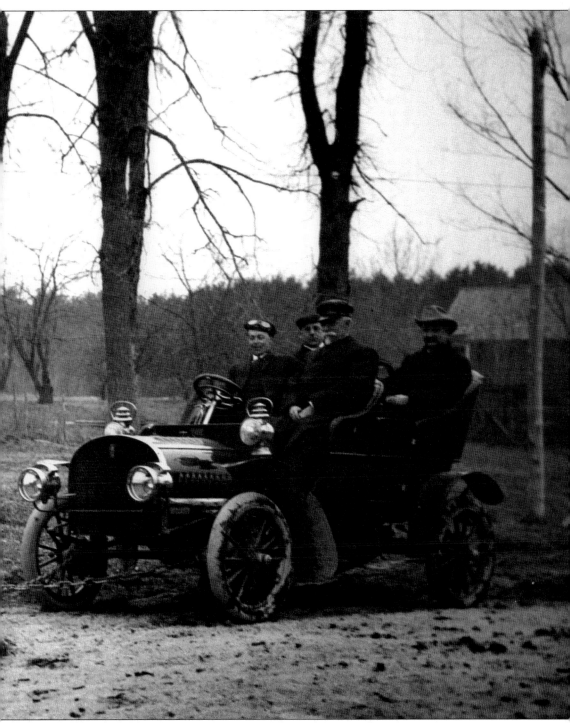

could not. New technology at times must seek the help of the old. In the early 1900s, Elmer Marston lived in West Falmouth near the Cumberland line. There was one spot on the road that always seemed to be wet. As a result, he and his oxen were called upon by frantic motorists to pull them out. He helped them out if they returned. (Courtesy E. Winslow.)

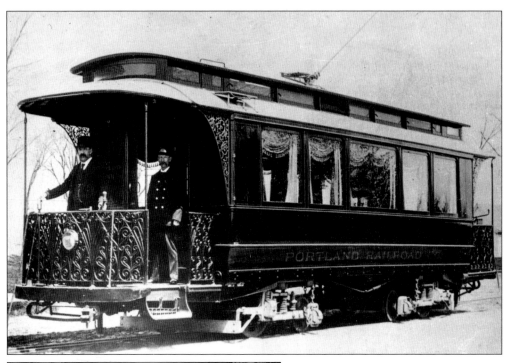

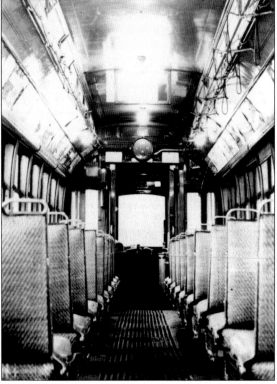

The car shown above, built around 1900, could be hired for parties or for the special transportation of important people. It was often used for outings to the casinos in Cape Elizabeth, to Riverton in Portland, and to Underwood Park in Falmouth. Special individual plush-lined seats made the ride comfortable. The picture at left shows a regular trolley car interior. The seats were made of light brown straw woven in a wicker pattern. The seats were hard, very durable, and could be pushed forward to face the other way on the return trip. A rubber mat on the floor could be taken out and washed. Fans kept the interior somewhat cool on hot days, and the windows were usually open on warm days. Electric heaters were used in winter. (Courtesy FHS.)

Two interurban electric trolley systems came through Falmouth. One line followed Route 1 up the Foreside to Yarmouth, and the other followed Route 100 through West Falmouth and on to Lewiston. When these lines were being constructed, the crew was fed. Above, the cooking crew is posed outside the cook shack and dining tent. The cook shack and the tent could be moved to wherever they were needed. Interurban electric cars ran on Route 1 to Falmouth, over the Martin's Point Bridge, and past the lower Foreside, Skillins, the Town Landing Market, the spur, and on to Underwood Springs. The 1920 picture at right shows the tracks going by what is now the Portland Country Club. The white house on the left belonged to the Knudsen family. (Above, courtesy FML; right, courtesy B. Knudsen.)

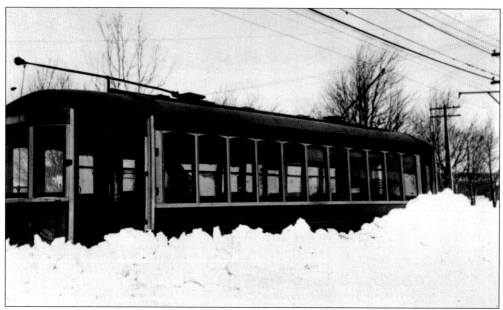

March 1920 was not a good year for travel in southern Maine, especially trolley travel. Heavy snow closed parts of the trolley system for several days, as plows and human shovelers cleared the tracks. The rails needed to be as bare as possible for proper electrical contact. This was quite a storm. Cameras were more numerous and everyone seemed to have taken pictures of this storm. The Falmouth Historical Society files have many snow pictures from 1920. The trolley pictured above was photographed just north of Skillins Corner on the Foreside. It has gone off the track. Below is the Russell house at 155 Foreside Road, and a crew is clearing the tracks for a stalled trolley car. (Courtesy H. Russell.)

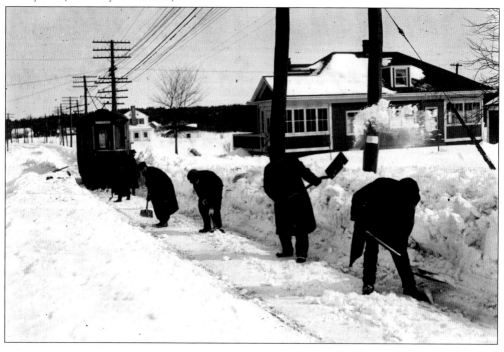

There are no more covered bridges with horses and buggies and no water mills in Falmouth. Shipbuilding, once a mainstay of the Falmouth economy, is all but forgotten, and there are few active farms. The Falmouth Historical Society is dedicated to the preservation and display of items used in the past. It seeks to help others find out more about their own connection with the past in Falmouth. The society opened the Falmouth Heritage Museum and Park on June 14, 2008. The museum is located on Woods Road in Falmouth. The house, now the Falmouth Heritage Museum, was built about 1840, just up the road from its present location. Over the next few years, the museum plans to expand its exhibits and demonstration activities. (Above, courtesy FHS; below, courtesy Portland Press Herald.)

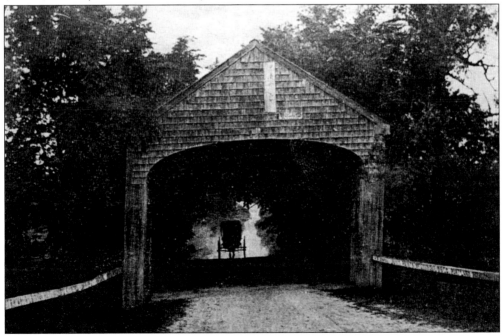

BIBLIOGRAPHY

Abbott, John S. C. *The History of Maine*. 1877.

Dow, George Francis. *Everyday Life in the Massachusetts Bay Colony*. 1935.

Everets and Peck. *History of Cumberland County, Maine*. Philadelphia, PA: J. B. Lippincott Company, 1880.

Goold, William. *Portland in the Past*. Portland, ME: B. Thurston and Company, 1886.

Rowe, William H. *Shipbuilding Days in Casco Bay*. 1927.

Town of Falmouth. *Falmouth 250th Anniversary*. 1968.

Wallace, Charlotte and Donald. *E Pluribus Unum A story of Falmouth, Maine*. 1976.

ABOUT THE FALMOUTH HISTORICAL SOCIETY

Members of the board of directors and the staff of the Falmouth Memorial Library were instrumental in forming the Falmouth Historical Society in 1966. The society maintained its records and archives at the library for many years. The society, incorporated in 1981, is an independent organization operating under Section 501(c) (3) of the Internal Revenue code as a non-profit corporation devoted to educational, historical, and preservation activities. It conforms to the laws of the State of Maine.

The mission and purpose of the society is: to acquire and preserve archives and artifacts pertaining to the history of the Town of Falmouth, Maine; to provide a permanent site that is environmentally safe and physically secure for the display, storage and care of historical materials; to provide regular programs, exhibits and other educational opportunities to the society members, to the schools, and to the public; to assist members and the public with historical and genealogical research; to own, maintain, and exhibit in the Falmouth Historical Society Museum currently situated on the Woods Road in Falmouth; and to cooperate with other community and area organizations and government entities that have similar purposes and interests.

The society offices and genealogical rooms are located at 2 Homestead Lane on campus of the Ocean View Retirement Community.

The society operates the Falmouth Heritage Museum at 60 Woods Road. The museum is open from late spring to early fall. The society can be contacted in a number of ways, such as the Web site, www.falmouthmehistory.org; e-mail, falmouthhistorical@myfairpoint.net; the society telephone, 207-781-4727; the museum telephone, 207-781-9034; and the mailing address, PMB 367, Falmouth Historical Society, 190 US Route 1, Suite 4, Falmouth, ME 04105-2199.

ACROSS AMERICA, PEOPLE ARE DISCOVERING SOMETHING WONDERFUL. *THEIR HERITAGE.*

Arcadia Publishing is the leading local history publisher in the United States. With more than 3,000 titles in print and hundreds of new titles released every year, Arcadia has extensive specialized experience chronicling the history of communities and celebrating America's hidden stories, bringing to life the people, places, and events from the past. To discover the history of other communities across the nation, please visit:

www.arcadiapublishing.com

Customized search tools allow you to find regional history books about the town where you grew up, the cities where your friends and family live, the town where your parents met, or even that retirement spot you've been dreaming about.